ANDROPHILIA

ANDROPHILIA
A MANIFESTO
REJECTING THE GAY IDENTITY
RECLAIMING MASCULINITY

JACK MALEBRANCHE

SCAPEGOAT
PUBLISHING

First Printing

5 4 3 2 1

Cover design by Kevin I. Slaughter and Jack Malebranche
Interior design by Kevin I. Slaughter

Androphilia ©2006 Jack Malebranche
ISBN: 0-9764035-8-7

Scapegoat Publishing
a division of Reptilian Inc.
2545 N. Howard
Baltimore, MD 21218
ScapegoatPublishing.com

For *androphiles*.

CONTENTS

INTRODUCTION VIII
A MANIFESTO............................ 16
 GAY IS DEAD 17
 ANDROPHILIA—SEXUALITY AS PREFERENCE 22
 GAY PARTY CRASHING 29
 THE STIGMA OF EFFEMINACY 45
 'MAN'—THE NATURAL RELIGION OF MEN 65
 TOWARD A MASCULINE IDEAL ?8
 CHARACTER, NOT CARICATURE 95
 TAKING BACK MASCULINITY 107
 ANDRO CULTURE—A FRATERNITY WITHIN 114
AN ESSAY................................122
 AGREEMENTS BETWEEN MEN 123
APPENDIX138
 SELECTED BIBLIOGRAPHY 139
 AKNOWLEDGEMENTS 142

INTRODUCTION

I never wanted to be a gay writer.

The last thing I ever wanted to become was a professional homosexual.

The manifesto that follows is a rejection of the idea that the experience of homosexual desire should determine a man's tastes, his behavior, his friends or his politics. It's a rejection of the idea that sexuality creates a complete identity or defines a man.

Men should be defined by what they do, not who they screw. Sex is great, and it's part of life. But it's merely *part* of life. I prefer men sexually, but that's no accomplishment. It's nothing to be proud of. Simply being a man who loves men is no legitimate claim to fame.

For a man with these convictions, stepping into the spotlight to speak out about homosexuality is somewhat contradictory.

However, those who never speak are rarely heard.

The overwhelming majority of books on homosexuality are written by academics, professional homosexuals, and those deeply invested in the gay community. They are written by those who depend on the gay community for their livelihoods, for acclaim, and for support. These gays have a vested interest in kowtowing to the sacred ideologies of the gay community and in portraying that community in a positive light. They're afraid to bite the hand that feeds them; they are careful not to offend

the wrong people. They are handicapped by their dependence on the gay world.

To paraphrase a line from the film *Fight Club*, I am free in all of the ways that they are not.

In *Androphilia*, I haven't held back. I've made no concessions. I've said exactly what I meant to say.

An author who read this manuscript warned that it would "ruin my life," and that I would be blackballed by the gay community. But my life is completely independent of the gay community. I rarely go to gay events. I darken the doorstep of a gay bar only a handful of times each year. Not all of my friends are same-sex oriented. I most often travel in circles where my sexuality is irrelevant. The homosexual and bisexual men with whom I associate are also critical of the gay community. I have a fun, fulfilling, nearly fraternal relationship with my long-term partner, to whom I've referred throughout the book as my *compadre*—"partner" has always seemed like a neutered or lesbian word to me. I have a supportive family. I have interests that have nothing to do with my sexuality. The gay community can't ruin my life, because it's really not a part of my life.

This book is being released by Scapegoat Publishing. Their advertising slogan is "Blame Us!" It's extremely appropriate in this case.

Go ahead. Blame me. Insult me. Blackball me.

I can take your hate. I don't need your love, your acceptance or your approval.

I didn't write this book for gays. Nor did I write it simply to provoke controversy.

I wrote this book for men who love men but who are sick to death of the gay community. I wrote it to give a voice to men who have rarely seen their feelings about homosexuality and gay culture in print. What I've written is based not only on my own observations, but also on countless conversations I've had with men much like myself. I don't consider myself a writer. I'm just a guy with something to say, something that is often expressed privately but is almost never said publicly. I wrote this

book because no one else would. It is a rant, but it is a rant echoing thousands of rants that have faded into the din of bars, restaurants and cyberspace.

While my opinions are ultimately my own, and I don't expect my comrades in dissent to agree with every word I've written—I expect them to be men in their own right with their own ideas—early reactions to this manifesto have been enthusiastic. The recurring exclamation from such men has been, "Finally!" Gays would like to believe that those same-sex-inclined men who want little or nothing to do with the gay community or who disagree with gay ideology are a few isolated self-hating Roy Cohns. I believe they are legion. And I don't think most of them hate themselves or hate being attracted to men. But because these men are busy living their lives without wrapping themselves in their sexual identity, because they are busy simply *being men*, they go unnoticed. I wrote this book for them.

While I've always been critical of the gay hive mind, I haven't always been the outsider I am now. I spent a significant portion of my life traveling in gay circles, hanging out in gay bars and gossiping with queens. In the early 1990s, I was a go-go dancer in New York City's club kid scene. I ran around in elaborate costumes and makeup. I've shaved my body, colored my hair, and pierced my eyebrow. I've been a fashion fag and an enthusiastic pop-culture addict. I've challenged gender constructs. I've done drag. I talked the talk and fagged out with the best of them. I've been to backrooms, leather clubs, bear bars, hipster hangouts and circuit parties. I even marched in a gay pride parade once. I know the gay community from the inside out. My critique of gay culture doesn't come from an outsider's ignorance; it comes from an insider's knowledge. I know what the gay lifestyle has to offer. It can be fun and exciting, especially when it's new and especially for the young.

Eventually, I realized that while I was experiencing many things in the gay world, I was shutting out so much more. I was living in a gay bubble, dissociated from nongay men and

cut off from a part of myself that was distinctly, unmistakably male. I became increasingly attracted to masculinity as an ideal and to the things men typically enjoy. I found that many of the interests and pursuits I'd written off as an adolescent were far more appealing to me, even surprisingly satisfying as a grown man. While some masculine-identified homos never adopt the gay lifestyle at all, I've seen many others go through this cycle. When the dazzling disco ball of the gay world becomes less blinding, they reevaluate and reconfigure themselves. They become interested in what it means to be an adult male. They strike out in search of their lost manhood. I believe this desire to rediscover one's innate maleness is in part what makes the leather and bear subcultures so popular with men over 30. It's part of the reason why many lithe, laughing young party boys start pumping iron and end up looking more like bodybuilders. It's part of what drove Yukio Mishima to abandon the sedentary lifestyle of an intellectual, take up kendo and form a paramilitary organization.

Men who love men have a place in a world beyond the gay world; they have a place in the world of men. Culture created by and for men is the richest culture on the planet. Human history is primarily a story about the deeds and achievements of men. This history is the true heritage and birthright of every male, if he chooses to claim it.

Androphilia is an effort to reclaim this rich male heritage for men who love men. It dismisses those who want to confine homosexual males to a clichéd effeminate stereotype. *Androphilia* suggests a different way to perceive homosexual desire and encourages homosexual and bisexual men to thrive unhindered by the limitations of the gay identity. This book is about seceding from the gay community and rediscovering masculinity. It is a dare to leave the gay world completely behind and rejoin the brotherhood of men. *Androphilia* is a challenge to embrace masculinity without compromise, to live up to a masculine ideal, to truly seek out and learn what it means to be a man.

Following the *Androphilia* manifesto, I've included an essay that addresses the unavoidable issue of same-sex marriage. "Agreements Between Men" is a brief sketch of my personal convictions on same-sex marriage, and is not meant to be read as part of the manifesto. As a potential candidate for such a union, I've wrestled a great deal with the idea of marriage over the past few years. While I do appreciate the arguments of others, my stance against same-sex marriage has only become more resolute. That position is informed by both a principled idealism and what I see as an aesthetic conflict between the tradition of marriage and a bond shared between men. I do not expect all those who would call themselves *androphiles* to share this view.

Given the overwhelming proliferation of politically motivated pro-same-sex-marriage propaganda flooding the market today, "Agreements Between Men" is intended primarily as a record of dissent. The public has been led to believe that all homosexuals support the fight for same-sex marriage, and that is simply not the case.

Jack Malebranche
Portland, Oregon
August 2006

ANDROPHILIA

"Men may seem detestable as joint stock-companies and nations; knaves, fools, and murderers there may be; men may have mean and meagre faces; but man, in the ideal, is so noble and so sparkling, such a grand and glowing creature, that over any ignominious blemish in him all his fellows should run to throw their costliest robes."

- Herman Melville, *Moby Dick*

"Isn't there any romance or adventure in the world, without having a flapper in it?"

- from *King Kong* (1933)

A MANIFESTO

GAY IS DEAD
(OR AT LEAST IT'S DEAD TO ME)

I am not gay.

I am a man who loves men, and I'm comfortable with that.

In fact, my love of men and masculinity is one of the daily, simple pleasures of my existence. When gays implore others to believe that they would be heterosexual if only they could, I'd suggest they just *try harder*. Living a straight lifestyle to please others certainly isn't impossible. People who've experienced same-sex attractions have been suppressing those desires to keep up appearances or to save their own necks for thousands of years. Sex with the opposite sex is still sex, and it's not all bad. Sometimes it's even fun. I've had a go at it myself a handful of times. If I had to choose between sex with women and no sex at all, sex with women would get the job done. There is a certain beauty in the timeless dynamic between a husband, a wife, and the children they've conceived together. If I wanted that for myself, I feel confident that I could find a nice girl and live that life. But I am fortunate enough to live in an age of relative tolerance, where I am free to live the life I choose with minimal inconveniences. I favor men, and I have chosen to live with and love another man. That is my preference and my pleasure. I wouldn't trade it away for the shallow comfort offered by the

saline drip of an ego-affirming sense of normalcy.

No, this is not another maudlin homosexual apologia or a plea for approval. I don't require approval or acceptance; I simply require tolerance and freedom from governmental involvement in my private affairs. A generation of gay advocates who came before me worked for the social tolerance and freedom from persecution that I've enjoyed throughout my adult life. I happily thank them for that. But this freedom came with quite a bit of baggage. Rather than carry that baggage and hand it off to the next generation, I've chosen to lighten the load for myself and perhaps for other men of a particular bent who find that the gay identity has little to do with *their* identities as men.

I am not gay, and while I do experience a sense of camaraderie with *some* men who identify as gay, I reject membership in what is known as the gay community—which today seems to include almost anyone who doesn't have husband-on-wife sex in the missionary position with the lights out.

I am not gay because the word *gay* connotes so much more than same-sex desire.

The word *gay* describes a whole cultural and political movement that promotes anti-male feminism, victim mentality, and leftist politics. As a man, why should I treat men as oppressors and masculinity as a universal evil? Why must I constantly think of myself as a struggling minority when I'm doing fine? And what does socialism have to do with who I think is hot?

Gay stands for the notion that sexuality engenders ethnicity and complete social identity. I have virtually nothing in common with most members of a gay community that includes lesbians, queens, and transsexuals of all religions, nationalities, and races. They are not my *family*. They are not *my people*. Why should I identify more closely with a lesbian folk singer than with other men my age who share my interests?

I strongly identify as a man. I value masculine qualities in myself and in the men around me. In my adult life, I've found that I am most comfortable among other men, regardless of

their sexual proclivities. I've developed a profound respect for men and for much of what men have aspired to and achieved throughout history. The culture of men is my shared heritage, and I am proud to be a man—as much as one can be proud of one's gender. I am an unrepentant masculinist.

Gay culture embraces and promotes effeminacy. The phrase 'gay man' implies effeminacy. As a deterrent, opponents of homosexuality have attributed a stigma of innate femininity to all men who engage in sex acts with other men. To be sure, effeminate subcultures have existed throughout history and those males generally expressed homosexual desires. But there have always also been those who enjoyed sex with men but who were essentially no less masculine than their straight peers. Today, homosexual acts are no longer a grave offense, but this stigma remains, and effeminates are the predominate figures in gay culture. While those who truly find this culture appealing should feel free to do as they please, why would a masculine-identified guy want to call himself gay? Why would he put himself in the position of having to defy the well-established stereotype openly celebrated by gay culture and inextricably linked to it in the popular mind? What does he gain by associating himself with those whose values run contrary to his own?

The insistence by essentialist gay advocates that homosexuality is absolutely innate and inflexible, combined with their celebration of effeminacy, has actually fostered the perception of a mutually exclusive relationship between masculinity and same-sex desire. Straight men police their behaviors, interests, career choices and interactions with other men to avoid being perceived as something they are simply not. Likewise, men who prefer men are expected to shy away from traditionally masculine pursuits, and are encouraged by gay peers to express their 'gayness.' Such a man who defies the clichéd expectations attributed to his sexuality is surprising—even disconcerting—to straights and is often identified as self-loathing or in some way repressed by gays.

This black-and-white division between what homosexual

men can do and what heterosexual men can do is stifling, restrictive, and counterproductive for all men. It is especially counterproductive for same-sex-oriented men who are not particularly effeminate, because it encourages them to become absorbed in gay superficiality and fascination with passing fashions ('fashionation?') while discouraging masculine interests which men may find more satisfying in the long term. Men like the things men like for a reason; one can only have so many cocktail hours and make snide remarks about pop culture for so long before life becomes monotonous. It's hardly surprising many gay men are popping antidepressants with their apple martinis, or turning to methamphetamines to make life more 'exciting.'

Further, a feminist disdain for 'the construct of masculinity,' widespread in the gay world, may actually cheat men out of a masculine value system that has historically been proven to bring out some of men's best qualities. Men who are often single for a significant part of their lives could benefit greatly by championing self-reliance and personal responsibility over perpetual victimhood, and blaming society for their predicaments. It may also prove a cheaper and more effective guard against the spread of disease than the glamorized, affirming, nonjudgmental, velvet-gloved finger wagging of the average anti-AIDS ad campaign. Perhaps holding personal achievement higher than the self-congratulatory, therapy-induced 'emotional survivor' mentality that holds sway over the gay community might actually be a good thing. And the concept of masculine honor, when not taken to self-destructive extremes, might prove a welcome change of pace from a community known for incessant gossip and henhouse bitchiness.

Without the shared threat of physical persecution, there is little reason for the quasi-religious solidarity that gay advocates demand of all those with same-sex interests, gender issues and whomever else they've huddled under the gay umbrella. The goals of today's gay advocates—hate crime and anti-discrimination legislation, politically correct thought-policing, same-sex

marriage and adoption 'rights,' and support for completely unrelated leftist causes are contentious at best. They are dubious wants, not the dire injustices faced by previous generations.

The time has come for masculine men who love men to break away from a politically charged gay community that does not represent their interests or values. It is time for us to wipe away the age-old smear of effeminacy by rejecting the divisive, limiting gay identity, and to reclaim our rightful place among the brotherhood of men. In this age of tolerance, there is ample opportunity for those critical of gay culture to found a new subculture based on masculinity, not as a mere subset of gay culture but in tribute to the rich history of masculine culture itself. Emboldened and inspired by time-tested masculine values, it is in this way that we can reach our true potential as men and earn the respect and admiration of our male peers.

The first step is to recognize homosexual attraction as a variation in desire, rather than indicating a different kind of man. It is crucial to understand that we are men *first*, instead of allowing ourselves to be defined by our sexual desire. I call this desire *androphilia*—literally, 'the love of men,' but in this context also a broader love of what men embody, of masculinity itself. I will use this term to distinguish my own attraction to men from the culture and politics associated with the gay identity.

I am not gay.

If I was ever truly a member of the gay community—something I doubted even when I traveled in gay circles—I terminate that membership now. I refuse to be counted among them. This manifesto stands as a record of my dissent.

Gay is dead. Or at least it's dead to me.

I'm just a man who loves men.

I am an *androphile*.

ANDROPHILIA—SEXUALITY AS PREFERENCE

All men appreciate masculinity in other men. They appreciate men who are manly, who embody what it means to be a man. They admire and look up to men who are powerful, accomplished or assertive. They affectionately take note of masculine qualities in other men and celebrate them. Men respectfully acknowledge another man's impressive size or build, note a fierce handshake, or take a friendly interest in his facial hair. A man who is known as a man's man, who behaves in an exceedingly masculine way and who exhibits an unfaltering confidence in his own masculinity is likely to be esteemed and universally welcomed by other men. Sportscasters and fans speak lovingly of the bodies and miraculous abilities of their shared heroes. Men enthusiastically ape the macho postures and quote the catch phrases associated with their favorite masculine cinematic gods and entertainers, from John Wayne and James Bond to Al Pacino and Robert De Niro. While straight men would rather not discuss it because they don't want to be perceived as latent homosexuals, they do regularly admire one another's bodies at the gym or at sporting events. Straight men are not blind; those who are secure in their sexuality can and do appreciate a good-looking fella. I've even had private, frank discussions with straight men who spoke rather reverently about other men's cocks. I don't mean to suggest that this admiration is always sexual; it usually isn't. But admiring masculinity in other males is part of being male.

The prefix *andro* means male; it comes from the Greek word *anêr*, which describes an adult male in the prime of his life. The suffix *philia* can mean a friendly love or appreciation. In some platonic sense, many men are *androphiles*. They appreciate masculinity the way audiophiles appreciate music.

However, the more common usage of *philia* implies an unusual, sexual love. Women could be considered *androphiles*, but a female affinity for men is the norm—it's hardly unusual or even notable. I'm using *androphilia* here to describe a sexual love and appreciation for men as it is experienced by males. The

term *androphilia* is not new; sexologist Magnus Hirschfeld used it a century ago to distinguish those males who preferred men in the prime of their lives from those who preferred adolescent males and aged men. It is currently used by some to specifically discuss objects of sexual desire in the confusing world of transsexuality, where lines of gender are blurred. This usage is rare; the word *androphile* isn't even found in most modern dictionaries. As such, it's a word easily appropriated.

Homosexuality is an exceedingly broad term that includes sexual relations between any people of the same gender. While it is most often used today in the context of adult relations, it can also refer to pedophilic and pederastic relations between members of the same sex. True pederasty is alien to me, and I find true pedophilia repulsive—as do most other sane adults.

Androphilia is specific. It refers only to the love of adult men. And although gays have dissociated themselves from many conceptual and cultural aspects of masculinity, I believe that loving men means loving masculinity in some sense. I once wrote that "there is no such thing as high-fashion homo porn," because no matter how effeminate gay men are, their sexuality is generally focused on a love of particularly masculine men. It is rare to see homo porn where males are glammed up, stripping out of high-fashion gear or *intentionally* fagging out. There's not much of a market for it. The most prevalent homo porn has always shown brawny studs or 'regular guys' with a variety of body types stripping out of uniforms, blue-collar clothes and sports gear. Gay culture celebrates queeniness, but gay porn is almost exclusively a celebration of hypermasculinity. Currently, one of the most popular forms of porn is what I call *straightsploitation*, wherein ostensibly straight guys are paid large sums to perform for a homosexual audience. This is not a new phenomenon; some of the earliest photographic homo porn, specifically magazines like *Physique Pictorial*, depicted young oiled-up straight guys flexing, wrestling or posing like gladiators and strongmen. Gays may act like girls, but their sexual fantasies most frequently involve men who are masculine. Porn is carnal

truth. The hypermasculine porn that homos pay to jack off to reveals more about their true collective sexual desires than any skewed sociological studies or politically correct protests to the contrary ever will.

I initially intended to present *androphilia* as a masculinity fetish. In many ways, that's how I see it. But I found that the word 'fetish,' for many masculine-identified homos, seems to evoke something superficial or trivial. *Androphilia* is not something as surface as a uniform fetish. A true love of men involves more than a fetish for men's uniforms or muscles or body hair or macho posturing. *Androphilia* is more profound. I don't *just* appreciate men's bodies or the way they dress.

As a man, I appreciate men in much the same way that straight men appreciate each other. Where we differ is that my love for masculinity in men has a sexual component. I appreciate strength, character and manliness in men, but I've also developed a sexualized fascination with these qualities, in addition to an attraction to physical aspects of maleness.

I don't know exactly why I'm attracted to other men, and despite their apparent convictions on the matter, neither does anyone else—though theories and strongly held, highly subjective beliefs abound. People often can't explain the genesis of many of their tastes, tendencies, preferences or talents. Why are some people more inclined to be Republicans while others find the Democratic, Libertarian or Socialist parties more attractive? What makes people find certain careers or even particular aesthetics appealing? What causes some people to reject religion and call themselves atheists no matter how they were raised, while others are drawn to Christianity, new age religions or Buddhism? There has been some evidence to suggest that there's a 'thrill-seeking gene' that makes people more likely to take risks, smoke cigarettes, jump out of planes, drive fast or possibly commit crimes. But certainly, people with this biological tendency don't *have* to do these things. They are still able to make *choices*. Biology may or may not play a role in determining many tendencies, but experience, environment,

psychology and, yes, personal *choices* are also likely influential in determining how these tendencies manifest themselves in different individuals. The mind is highly complex, and human experience has many layers. I suspect that men develop or act on sexual attractions to other men for a wide variety of reasons.

I'm not convinced that the same things are going on in the noggins of Filipino ladyboys and Harley-riding bears, or men who have simply had a handful of homosexual experiences. It's misleading and overly simplistic to lump these men into the same group. *Androphilia* is experienced differently and in different degrees. Some men experience *androphilic* desire situationally, or only rarely throughout the course of their lives. They may or may not act on that desire. Others are exclusively *androphilic* to the point that, in a sexual context, they find women nearly repulsive. I find women sexually attractive occasionally, but over time I've determined that I would rather have sex and form close bonds with men. I'd rather live with a man and spend time with men. I *prefer* men. Specifically, I prefer masculine men. Some men enjoy both men and women. *Androphilia* is not some sort of on/off switch. *Androphilia* and *gynophilia* are not mutually exclusive. Many gays insist that one must 'choose sides,' but I believe this is divisive and limiting for all men. It makes more sense to discuss homosexuality in terms of desire, and in variations of that desire, than it does to shove any male who experiences that desire into one limiting category.

Sexual desire is diverse. Men have many differing sexual desires and preferences. Some men have a thing for blondes while others prefer fiery redheads; some guys are ass men and some are breast men; some exclusively have vaginal sex while others enjoy anal and oral sex; some prefer to dominate in the bedroom and others hire dominatrixes; some like young women while others prefer mature women; some are strictly monogamous and some are swingers. There are furries and foot fetishists, men who prefer certain races of women and guys who dig trannies or dwarves. Some men are virtually asexual. Some are pansexual pleasure-seekers who will try almost anything. I *prefer* sex with

men. The popular idea that this single preference should separate me from all of these other men and that it should define my other preferences and ideas—that this sexual preference should become my entire identity—is completely asinine. Yet, this is exactly what the word *gay* does. The word *androphile* describes *only* my sexual preference for men. Everything else, all of the culture, politics and stereotypical behavior associated with the gay identity is excess baggage.

Gays insist that homosexuality is *never* a choice, but this is defensive political posturing designed to absolve homosexuals from responsibility for their choices, portray them as victims of circumstance and appeal to public sympathies. While experiencing a desire may not be a choice, acting on it absolutely is. Today, most people in the developed world are spoiled; they live relatively luxurious, hedonistic lives. When gays claim homosexuality is *not a choice*, what they mean is that they are unhappy living heterosexual lifestyles, and that they are happier when they are with men. They would *rather* be with men. They are doing what makes them happy. I see nothing wrong with this—but own up to it! Do what makes you happy and don't apologize for it; don't pretend you just can't help yourself. That's craven adolescent rationalizing. Be men. Stand up and say, "This is who I am; this is the life that best suits me; it's the life I want to live. This is my preference." Take back choice, and take responsibility for your choices. Preference should not be a dirty word; our preferences shape our personalities.

The word *gay* creates social identity; it is a political tool used to claim minority status. Gays believe they have no more control over their actions than black people have over their skin color. This is at least partially bullshit, even if there is a biological component to sexuality. The things people *do*, the *choices they make*, are not comparable to inarguably inborn, visibly obvious and unchangeable racial characteristics. The word *androphilia* describes desire; it describes a preference. *Androphilia* acknowledges a variety in sexual preferences among men and identifies a specific sexual preference for men. Describing

homosexuality in terms of preference doesn't create a minority status or a special 'race' of men; it allows homosexually inclined men to remain men—men who simply prefer different things sexually. Instead of casting them as victims of circumstance, preference empowers them to take responsibility for making the choices that are most fulfilling for them and that will lead to their own personal happiness.

Frequently, I come across men with more conservative political views or men who value masculinity banging their heads against the walls in debates, constantly trying to explain to others how they could possibly be *gay*. These fellows inevitably make the case that the word *gay* describes only their sexuality, which is a small part of who they are as men. But the frequency of these arguments and the bile that they evoke from the broader gay community demonstrates how politically and socially loaded the term *gay* really is. And if the word gay is politicized, the word *queer* is doubly so. While *queer* was once slightly more subversive slang, used notably by iconoclast William Burroughs in his novel *Queer*, it developed a distinctly radical leftist taint in the early 1990s that is still plainly evident in modern queer theory.

The word *gay* connotes effeminacy. There's no getting around it. Originally, in addition to some early nefarious, euphemistic usages having to do with prostitutes, it's been used to describe someone or something brightly colored, lighthearted and merry. This old meaning is perpetuated in the gay culture through the use of fruitcake symbolism like the ubiquitous rainbow flags. Colors like pink and lavender, colors most frequently associated with little girls, are also widely associated with the gay movement—that certainly doesn't do anything to contest associations with effeminacy. You'd think that gays, for all of their supposed collective fashion sense, would understand the language of color. It's almost as if they *want* to be perceived as being especially effeminate, despite their occasional and unconvincing statements to the contrary.

Today, the word *gay*, like *fag*, is still frequently used as a schoolyard taunt meaning effeminate, prissy, weak or foolish,

A Manifesto · 27

often before the children using it understand its association with homosexuality. This meaning is common even among young adults who may not be especially opposed to homosexuality. The fact that most openly gay male celebrities are known specifically for having flamboyant, effeminate, prissy on-screen personae only validates this usage. Gays may imagine that the word *gay* only describes their sexuality, but this is simply not true.

Why would a man who values his masculinity, who wants to be taken seriously by other men, want to identify himself as *gay*? To do so is to put oneself in the position of having to disprove the connotations of frivolity and effeminacy that the word *absolutely does* carry. If you're male, referring to yourself as *gay* is a bit like wearing eyeliner: you can get people to look past it, but they probably wouldn't be surprised if they caught you wearing a dress.

I believe it is necessary to use language as a tool to distinguish between the ideologies and stereotypes associated with the gay movement, and the specific sexual desire adult men experience for other adult men. *Androphilia* accomplishes this. The root *andro* evokes a specifically masculine sense of desire, a Mars/Mars desire for *men* as opposed to a mere desire for persons of the same sex. But it is not so specific that it refers to only one type of man, as the term *bear* does. I find many types of men attractive, as do tons of other masculine-identified homos. *Androphilia* is a sexual love of masculinity as it is manifested in a wide variety of men. Of course, each man will have his individual likes and dislikes within that scope. While separating masculine-identified homos from those who embrace gay culture and the gay identity, *androphilia* brings together all men who love men by describing their shared desire, but does not create a complete, confining identity that dictates their personal tastes or political ideology.

Gays often complain that they use the word *gay* simply because it's easy to say. *Androphile* and *androphilic* are admittedly a bit clunky in conversation. I suggest the slang *andro* for common usage. It means man, and it has a nice manly ring to it.

GAY PARTY CRASHING

When I first conceived of the possibility of exploring homosexual acts, back in rural Pennsylvania, I'd actually had a healthy history of heterosexuality, having happily been accommodated by several girls my age as well as a few adult women. But in early-1990s small-town America, homosexuality still seemed dangerous, transgressive, edgy. It was a dodgy undercurrent in all of the most interesting forbidden books and films. I was a kid who wanted to try everything that everyone else was afraid of, so I asked a girlfriend, much to her dismay, to set me up with this guy she knew. The sex was OK—exciting because it was new, but it wasn't as if I'd somehow discovered some magical missing component of my existence. At 17, like most guys that age, I could have had satisfactory sex with a sofa. I went off to New York later that year, naively expecting that unabashed bisexuality would still be hot, rebellious, decadent—even scandalous. Boy, was I in for a rude awakening...

On Christopher Street and in Chelsea, as my fellow students flocked to gay events, I couldn't help but come in contact with the same mainstream gay culture that Mark Simpson brilliantly lampooned in his 1996 essay, "Gay Dream Believer: Inside the Gay Underwear Cult."[1] I couldn't help it, because it was *everywhere*. In 1990s Manhattan, homosexuality was inescapable. The streets in Greenwich Village were plastered with provocative safe-sex posters. Rainbow flags flew from windowsills and hung in front of businesses. Homosexuality and bisexuality were not only mainstream, it seemed like you couldn't walk a block without being reminded of them! Eager to throw myself into an abyss of sin, I explored the gay stores and the gay bars and the weekly versions of circuit parties. I went to a meeting of my campus' petulant, prissy GLBT (gay,

[1] "Gay Dream Believer: Inside the Gay Underwear Cult" appeared in Simpson's 1996 book, *Anti-Gay*. *Anti-Gay* is one of the very few books I've encountered that dares to question the basic assumptions of mainstream gay culture.

lesbian, bisexual, transgender) student group. And yes, I went to the great big Gay Pride Parade, and watched as the triumphant drag queen RuPaul sang his hit single and proclaimed from his "Supermodel" float that being gay was positively great.

Even then, I wasn't buying it. That blissful self-congratulatory sea of gay conformity, of white tank tops and waving arms, wasn't quite what I'd signed on for the first time I made out with another guy. I signed on for William Burroughs and Jean Genet and Tinto Brass' *Caligula* and rumors about Lord Byron and ancient Greece and that surprisingly titillating nude scene with Julian Sands in *A Room With A View*. Most importantly, I signed on because I actually found other *men* sexually attractive.

I 'came out' by accident when my concerned mother got a little too curious about the stuff I was into. Coming out wasn't a trying, emotionally cathartic pivotal point in my life that freed me to be who I really was; if anything, I remember feeling inconvenienced by having to address it as if it were some 'big deal.' To me, it really wasn't. It sure as Hell is not something I feel the need to celebrate once a year with 'pride' and a big parade. That "Gay Dream Believer" world I found in New York wasn't a celebration of same-sex desire. It was a perpetual celebration of the acceptance of the gay identity. For so many of my peers and their predecessors, actual homosexuality was incidental. Being gay was *everything*. It wasn't a sexuality; it was a social group. Being gay was freedom rings and a rainbow flag; it was a haircut, a selection of must-see movies and must-buy records and must-go-to events. Gay culture was completely homogeneous, both visually and intellectually. Being gay not only demanded a certain aesthetic, but the acceptance of a set of maudlin sentiments, inside jokes and political ideas. It wasn't just *a* gay party, it was **The Gay Party**—Camille Paglia has snidely referred to it as 'Stalinist'—and I wouldn't have been surprised if we'd been expected to salute with a limp-wristed slouch every time someone played Gloria Gaynor's gay anthem, "I Will Survive."

Despite my disdain for the modern Gay Party, I don't mean

to suggest that the Gay Rights Movement hasn't accomplished anything of value or that it was not a successful tool in liberating same-sex-inclined persons from very real oppression.

When the earliest incarnations of the modern Gay Rights Movement were birthed in Germany in the recently enlightened nineteenth century, men who chose to engage in sex acts with other men still did so at their own peril. The horrors of the Inquisition were over for most people, but persecution of homosexuals continued in a secular milieu throughout Europe, albeit with significantly less fervor. Gathering places were raided, and while imprisonment for homosexuality *alone* was relatively infrequent, police harassment was common and blackmail was a booming business. Homosexuals were subjected, or subjected themselves, to bizarre medical examinations in an effort to study their deviances. The public was appalled by open expressions of homosexuality, but homosexuals grew increasingly militant. Karl Heinrich Ulrichs, whose ideas about homosexuality will be addressed later, openly campaigned as a homosexual for the repeal of anti-homosexual laws in mid-nineteenth century Germany. In 1897, Magnus Hirschfeld founded the pro-homo 'Scientific Humanitarian Committee,' a name matched in its intentional vagueness only by today's premier American pro-gay organization, the HRC or 'Human Rights Campaign.' Hirschfeld made great strides in his work with law enforcement, but in the twentieth century, European civil rights campaigns took a back seat to the more pressing concerns of war.

Although the extermination of Jews and other 'undesirables,' including homosexuals, served as a wake-up call to the world regarding the sinister acts that unfair, institutionalized prejudices can facilitate, sodomy remained a criminal offense in much of the world after World War II. Harassment of homosexuals by law enforcement and others continued as if the war had never happened, and increased dramatically in some periods and locales. John Rechy's *The Sexual Outlaw* provides a snapshot of the Los Angeles gay underworld of the 1970s. It details how a randy bunch of homosexuals were routinely harassed, registered

as sex offenders and, in some cases, imprisoned. These were grave injustices against people whose only crime was consensual sex—though admittedly, many were defiantly having sex in inappropriate and *very* public places. Discrimination against known homosexuals was certainly commonplace throughout the 1980s. Institutional indifference to the AIDS outbreak in the same decade was also a serious concern that had to be addressed.

It would be remiss not to credit the Gay Rights Movement for fighting against this sort of oppression, intolerance and intentional negligence. These men and women and in-betweens blazed a trail for my generation. While I may not agree now with some of their guiding principles and strategies, hindsight is 20/20, as they say. It is not my intent to second-guess their actions decades after the fact. I take issue not with what gays did, but what they are *doing*. My critique is not of what the gay community was, but what it has *become*: a parody of itself.

As a 31-year-old man, I haven't faced real discrimination in my adult life, and the only routine harassment I've experienced was the kind that any kid who is different experiences in high school. I've held a staggering number of jobs in several cities, and have found that most straight men couldn't care less about whom other men have sex with, so long as they are respectful of sexual boundaries and are not overly prissy attention-whores. (Straight men, much like myself, generally find prissiness and attention-whoring annoying in anyone, regardless of sex or sexuality.) The most difficulty I've had with being 'out' at work has been fending off the women who expect me to love nothing more than engaging in girl talk about hair and fashion with them. I've rented three apartments in three cities with my compadre over eight years and we have never had a problem with landlords; they're usually disappointed when we leave. We've never encountered issues with opening shared bank accounts or buying a car or insurance together. Any two people can do those things, with virtually no questions asked; I know a pair of straight guys who own a house together. We've never

had problems doing our taxes separately, and I'm fresh out of tears for well-off gays who complain that they could somehow save a few bucks if they were legally married. I have a truly fulfilling relationship with my immediate family. I realize that people with extremely religious families still have difficulties, but religion poses a problem that political activism *can't* solve. All in all, I'm doing just fine—millions of straight people are worse off than I am—and I've known tons of homos who have far more extravagant lifestyles. Honestly, if I'm being oppressed, I'd really have to start picking nits to figure out how.

And that is *exactly* what the modern gay advocates are doing. The Gay Rights Movement, pushed into overdrive by AIDS in the 1980s, has shifted into overkill. Having achieved relative tolerance for same-sex-oriented people in mainstream culture, and having brought an end to police harassment and widespread discrimination, the Gay Rights Movement has turned to nitpicking.

The Gay Rights Movement is no longer a bunch of ragtag grass-roots activists campaigning against violent oppression. It's an industry unto itself that rakes in millions of dollars and supports thousands of employees overall. The HRC has a snazzy Washington, D.C., headquarters, and the Gay & Lesbian Alliance Against Defamation throws posh awards ceremonies attended by the Hollywood elite. The Gay Rights Movement has become the Gay Advocacy Industry, and it survives by selling memberships in The Gay Party. Bumper stickers are the new armbands, and they are everywhere.

But what really sells memberships in The Gay Party? What is the true product of The Gay Advocacy Industry?

The illusion of oppression and victimization.

The Gay Advocacy Industry must maintain the illusion of oppression and victimization so that hundreds of thousands of checkbook revolutionaries can believe that they are fighting for their own freedom. But the truth is that they're already free to do just about anything. So, like any movement that has achieved most of its goals but can't just close up shop, The Gay

Advocacy Industry looks for new problems, and creates them (or exaggerates their importance) if necessary. The Gay Advocacy Industry's biggest enemy is not the wicked Religious Right, it is the possibility that same-sex-oriented people don't really need them for much of anything. If homos don't feel victimized or oppressed, they'll stop writing all those checks.

I don't mean to portray gay advocates as self-serving bastards and bitches deviously making straights and homos feel bad just to make a buck. For the most part, they're likely decent people who truly believe that they are 'working to make a difference.' However, it is simply not in the nature of contemporary advocacy to back down when things are going well; there seems to be a certain momentum to advocacy of any kind. The attitude seems to be, 'there is always more to do.' And there always *is* more to do, but when the big work is done, only pettier and more dubious tasks remain. Whether these organizations are 'for-profit' or not, they still have to maintain solvency. They are still essentially businesses, with people trying to move up the ladder by finding new ways to maintain or build revenue, no matter what the cause is. When I was a bit more naive I actually sent thirty bucks to the HRC, and years after my membership lapsed, I still receive regular e-mails from them complete with maudlin stories about discrimination and scary tales of the evil deeds of the religious right.

The religious right (or Anti-Gay Industry, as gay advocates like to call it) and the Gay Advocacy Industry actually seem to have a somewhat symbiotic relationship, although the gays get the short end of the stick. Nothing brings in gay money like the anti-gay campaigns of radical Christianists. Likewise, however, nothing brings in money for the Anti-Gay Industry like fear of institutionalized acceptance for gays. The problem is that there are simply *more* radical Christianists willing to write checks. This is why gay advocates, who routinely win in mainstream culture—because most people find gays nonthreatening and are willing to live and let live—increasingly lose their biggest political battles.

The fight for same-sex marriage is the obvious example. Gay advocates have telegraphed that same-sex marriage is their ultimate goal, and that they will settle for nothing less in the long run. Knowing that it's difficult to push gay marriage through legislatures because voting pro-gay can often seem like political suicide for politicians and a losing battle with voters, gay advocates use the legal system and put cases before judges who don't want to look like career bigots. In Massachusetts, they got what they wanted. In a year's time, the religionist right was able to wage massive campaigns, even in more sympathetic states like mine, Oregon, to pass constitutional amendments that prohibited same-sex marriage. One step forward, many steps back.

The Gay Advocacy Industry simply can't whip up enough enthusiasm to finance campaigns that compete with the Anti-Gay Industry. There simply aren't as many homos waiting to get married as there are Christianists who think the concept of same-sex marriage is perfectly vile. And, quite frankly, I really don't believe enough of said homos care as deeply about the issue. Because, as I said, most of them are doing just fine. Sure, most gays, if you ask them, think same-sex marriage is a grand idea, but many gay men simply don't think of marriage as a top priority. They'd rather upgrade their cars, redesign their houses, eat at hip restaurants and plan fabulous vacations. Who can blame them? I've spoken to many gays who, while angry about the fact that they *can't* get married, have never really even had a successful long-term relationship. And if they have, often their idea of marriage is a bit more flexible in terms of monogamy than what most people have in mind. Gay advocates would probably have a much easier time—because the religious right would have more difficulty generating outrage among its constituencies—in passing moderate domestic partnership and civil union laws that would be more flexible and more satisfactory for a broader range of people.

But that's the rub. Gay advocates aren't interested in practical solutions. Practical solutions aren't what their most

loyal supporters want. They are idealists. They believe they are fighting the good fight against oppression and inequality in the same way that blacks and women fought for equal rights in the 1960s and '70s. Supporters of gay causes consistently compare homosexuality to race, and play on white Americans' fears that they are secretly racist bigots, a mere noose and white sheet away from the Southern good old boys of yesteryear. Arguments for same-sex marriage, hate crime legislation, and antidiscrimination laws all hinge on the concept that homosexuality is pretty much exactly like race.

They believe these arguments to be effective because The Gay Party has built its ideology around the idea that homosexuality is absolutely inborn. The problem is that no one really knows this to be true. Gays have gone ahead and made up all of our minds for us and vigorously promoted their 'truth,' that homosexuality is *not a choice*. But the jury is still out in the scientific community, and 'current scientific thinking' on the matter seems to shift every few years. In the early '90s, when I came of age, everyone was *absolutely certain* that a 'gay gene' would soon be found, proving homosexuals to be genetically different and therefore worthy of all of the special considerations accorded to minority ethnic and racial groups. Today, many scientists believe that it is the hormonal environment in the womb that causes homosexuality. But this is no sure thing, no proven fact, either. It's only a theory, one that doesn't hold across the board. It seems that environmental factors and, yes, personal choices still play a role in shaping sexuality. My opinion, from experience and personal observation, is that even if many homosexuals *do* share some common biological traits, homosexuality can also be something of an acquired taste. Sex is still sex, especially for men, and it seems that given circumstances where boundaries of sexual identity are more easily crossed, some men develop a temporary or lasting affinity for sex with other men. Though they avoid discussing it in a political context, most gay men are quick to brag in social situations about encounters with ostensibly straight men. Of course, they will strongly assert that

homosexuality was never a choice *for them*. Pro-homo activists have asserted that sexuality was inborn long before they had *any* substantial evidence to back it up—since the very beginnings of homosexual activism in nineteenth-century Europe. Even then, the 'born that way' theory was likely adopted in part because it was politically expedient. David F. Greenberg, in *The Construction of Homosexuality*, wrote of pioneer homosexual activist Karl Heinrich Ulrichs' purely conjectural *urning* theory:

> Ulrichs's (sic) conclusion that uranians are born, not made, may have been inspired by embryological discoveries as he claimed; conveniently, it was an attractive position for someone arguing against the criminalization of homosexual relations. If homosexual desire is congenital and beyond one's control, one could argue for legal immunity in a criminal-law system that viewed crime voluntaristically. "They can't help what they do," the argument went; "therefore they shouldn't be punished for it."

Greenberg also noted that as theories of innate homosexuality gained popularity, many homosexuals became fascinated with the idea and reevaluated their pasts to validate it, including at least one author who rewrote her autobiography specifically to include early indications of homosexuality. The idea that homosexuality is 'not a choice,' that homosexuals are absolutely 'born that way,' seems always to have been more a matter of *faith*, and of political convenience, than of honest or objective analysis.

The strongest serious argument against legal oppression of homosexuality has always been the libertarian one: all adult people should be free to engage in nonviolent consensual sex acts in private, regardless of fluctuations in public opinion about those acts. This seems fairly reasonable to a logical mind. Secular arguments against homosexuality have always been weak, and with growing concerns about overpopulation and

dwindling natural resources, should be far less persuasive than they were in smaller, more tribal societies. Attempts by religious organizations to make nebulous secular arguments usually fall flat; fear of divine vengeance has always been religion's strongest weapon against homosexuality. One concern, even evidenced sporadically among the Greeks, has been that acceptance of homosexuality leads to a weakening through effeminacy of the male population. But if anything has made men more effeminate in the past half-century, it's been the running feminist critique of masculinity. It has been women, not homosexual men—who make up a fairly small portion of the population—who have demanded that men 'get in touch with their feminine sides.' While homos are routinely blamed for male effeminacy in the media, it's difficult to see how such a small group could have such a pervasive influence. And this argument is only even remotely plausible if one assumes that male homosexuality and effeminacy are synonymous. I'll take that assumption to task in the next segment of this manifesto.

The libertarian solution, however, has been achieved throughout most of the West. Sodomy has been decriminalized in the United States, and America lagged behind most of Europe in this significant achievement. It seems that if gay advocates today were truly concerned about *real* oppression, they'd be concentrating their efforts on political asylum programs for homos in Muslim countries, where accused homosexuals are still routinely executed or forced, foolishly, to submit to testosterone injections.

No, instead of fighting *real* oppression, they concern themselves with fighting inconvenience. Forty years ago, men like myself might have been jailed or beaten by police simply for being in the wrong place at the wrong time. I had a great-uncle who was arrested on sodomy charges. His full name and offense was printed in the local paper, which had significant repercussions not only for him, but also for my grandfather who operated a business under the same last name. The great injustices of my generation apparently have to do with health-

insurance benefits, the 'rights' to marry and to adopt children we can't have naturally, access to pension funds[2], tax breaks, and rarely experienced quirks of the legal system. These slights may be unfair, or at times cause hardship, but the hysterical rhetoric employed by many current gay advocates would lead one to believe the issues affecting today's homosexuals are equally dire forms of oppression. You'd never know it from listening to many gays, but most homos today actually *aren't* harassed, beaten or arrested due to their sexuality, and they face minimal, if any, discrimination. People who are open about their homosexuality today are actually pretty much free to live healthy, productive lives—if they choose to do so. And that's a good thing.

Nevertheless, The Gay Party tells us that we homosexuals must band together to fight against high-school bullies, and to encourage kids to 'come out' and ghettoize themselves into little gay support groups where they can become conversant in Party dogma and avoid ever having to learn to deal effectively with their straight peers. The Gay Party tells us our oppression is a lack of acceptance, which *forces* us into self-destructive patterns of behavior. The Gay Party insists we *learn* that we are victims of heterosexual oppression, and imagine that everyone is out to get us. Loyal members of The Gay Party *know* that their problems are no fault of their own, and that they are brave *survivors* working through all of the issues caused by adolescent ostracism and the hateful heterosexual hegemony. Isn't that what Gay Pride is all about?

To their credit, a lot of gays are relatively successful and actually quite socially integrated—they barely give a damn about the hateful heterosexual hegemony most of the time.

[2] Pension plans are quickly becoming irrelevant as they are being replaced by more flexible (if in many ways inferior) 401(k) plans in many major corporations. This issue is important to many Baby-Boomer-generation gays as they approach retirement (hence the sense of urgency), but few in my generation and the generations that follow will be able to look forward to pension plans. Arguments for same-sex marriage based on access to pension funds will soon be moot. 401(k) plans allow individuals to specify any beneficiary, regardless of relationship.

Until, that is, their own behavior is called into question. *That's* when they jump up on their moral high horses and bitch about how damn hard they've had it. How *dare* anyone pass judgment on those poor, oppressed gays!?! I'd like to introduce a lot of them to physically handicapped people, so they can learn what personal pride in the face of adversity really means. How is it that people who have difficulty every day doing the simplest things can so often manage to rise above their predicaments with dignity, and yet gays tell us they can't truly pull themselves together as long as there are people out there who simply don't approve of their lifestyles?

It is this sense of perpetual victimhood, this self-defeating lack of perspective, that motivates the most obnoxious activities of The Gay Party. Taking cues from the most misguided feminists and minority activists, gays are now fighting to control the ways in which homosexuality can be discussed. Gay Advocacy organizations constantly trip over one another as they issue public scolds in response to any opinion about homosexuality inconsistent with The Gay Party platform. Seemingly harmless portrayals of homosexuals in the media are decried as 'homophobic,' and campaigns are mounted to strong-arm companies into renouncing their actions and taking a more gay-sensitive approach. While most gay organizations actively enforce political correctness, GLAAD exists for no other reason. As The Gay Party's thought police, they offer a guide to 'offensive' terminology for the media (the word 'homosexual' tops the list—the innocuous 'gay' is the only acceptable way to refer to the same-sex-inclined) and work tirelessly to revise editorial policies and style guides to reflect a gay-friendly stance. Though GLAAD's motto may be "fair, accurate and inclusive representation," their actions are designed to control debate about homosexuality and stack the deck in favor of The Gay Party. These are no lovers of the free exchange of ideas. GLAAD is a propaganda organization whose implied mission is to massage public opinion and to whitewash homosexuality to make people more accepting of The Gay Party's causes.

A brief visit to any major gay organization's website unleashes a barrage of images—reminiscent of the feel-good stock photography used by major health care providers—portraying gays as harmless, happy *family-oriented* people. Is this really an accurate representation of the gay community? Readers, I defer to your experiences. Is the gay community really dominated by these smiling, freshly scrubbed, idyllic—if nontraditional—families?

Controlled language and imagery are The Gay Party's most powerful weapons in their war, not *against* oppression or intolerance, but *for* acceptance. It is a war of retribution fought by those who have felt excluded or unloved, a war to institutionalize unconditional acceptance through legislation and corporate policy. Gays are pushing the notion, as did blacks and women before them, that it is morally wrong to speak unfavorably about them as a group in any context and that it is morally wrong to portray them in a light inconsistent with their political agendas. This desperate desire for public acceptance is highly evident in the ongoing fight for same-sex marriage, which has always seemed to me less a fight for a handful of practical benefits than a battle for something far more symbolic. It is a fight for governmental sanction, for the state's seal of approval to be stamped on same-sex relationships. Psychiatrist Thomas Szasz put it best in his 1973 book, *The Second Sin*:

> The marriage certificate is proof of heterosexual normality. Many young people need it, to convince themselves that they are OK.

And so it is with gays. The hope is that once they get what everyone else has got—no matter how much they really even want to get married—they will finally be OK. Hopefully, they will even be able to convince themselves.

It is this overwhelming sense that homosexuals are still a deeply oppressed population, requiring reparative assistance from the state to achieve 'equality,' that has led The Gay Party to call

for support for (or 'form coalitions with,' to use the lingo) other leftist causes, including affirmative action, abortion, immigration rights and feminist antirape initiatives. Gay affiliation with the Democratic Party is well established and practically compulsory; many gays and gay advocacy groups actively campaign for Democratic candidates no matter how ambivalent those candidates are about issues affecting homosexuals. There's even a bizarre support among radical queers for Palestine and so-called moderate Muslims, many of whom find homosexuality abominable. If the level of acceptance for gays evidenced within the black community is any indication, most of this support is extremely one-sided. Many blacks are offended by claims that homosexual oppression is similar to racial oppression. Overt, unabashed homophobia—as opposed to perceived homophobia or mild anti-homo prejudice—is commonplace in urban black culture. And yet, as The Gay Party has identified the rich, white, straight male oppressor as the enemy, it seems to follow that all those who call themselves gays should rally behind other victims of his sinister regime. Never mind that many gays *are* financially successful white males.

The gay identity, as it is packaged, commodified and sold to the same-sex-inclined, supersedes all other identities. Homosexuality is believed by gays to be a defining characteristic, rendering all other ethnicities, beliefs or allegiances inconsequential. Gay Republicans are frequently compared to Jewish Nazis. Masculinity is acceptable only if viewed as a construct in need of deconstruction, and only so long as lip service is paid to the feminist dogma often favored by lesbians. A multiculturalist veneer of inclusivity prevails in gay discourse, but gay social scenes are often highly segregated. A socialist mentality prevails among gays, and capitalism must be discussed with a tone of disapproval, even though gay males are frequently the most conspicuous of consumers. Indeed, there seems to be a serious disconnect between who many homosexual men actually *are* and the ideologies espoused by The Gay Party.

It is not my intent to champion one set of political beliefs

over another, but rather to frankly discuss how conceptually loaded the gay identity actually is. While the slogan is 'diversity,' that certainly does not apply to ideological diversity. If anything validates the idea of gay 'ethnicity,' it is not the poorly understood experience of homosexual desire; it is the culture and the near-religious belief system shared by those who choose to identify themselves as gay. Homosexual desire has been experienced and people have engaged in homosexual acts since the beginning of recorded history without the gay identity and all of its ideological baggage. While postmodernists argue that the condition of homosexuality itself is a construct—which is itself an interesting topic for debate—the gay *identity* is unquestionably a very modern construct. However, those who are so eager to attack other social constructs seem willfully oblivious to the fact that new generations are being socialized to believe that homosexual desire is inseparable from the gay identity, gay culture and gay politics. In challenging restrictive social constructs, they've managed to create a new one.

I am certainly not the first person to say that the gay identity is becoming counterproductive, or that gay culture, the gay identity, and the need for them are on the wane. Outspoken mavericks as politically diverse as Peter Tatchell[3] and Andrew Sullivan[4] have challenged mainstream gay thought by saying that, as homosexuality becomes less stigmatized, the same-sex-inclined will become progressively more assimilated and will feel less of a need to segregate themselves from straight people, and the gay identity will become less important. This trend is easily observable in young homosexual men who often feel more comfortable in a straight bar with mixed friends than they do in the dying gay ghettos. Daniel Harris, in *The Rise and Fall of Gay Culture*, defined the gay sensibility as a "political response

3 Specifically, Tatchell's essays "Goodbye to Gay" and "Is Gay Just A Phase," both presently available at http://www.petertatchell.net/.
4 Sullivan's "The End of Gay Culture And The Future Of Gay Life" can be read at http://www.andrewsullivan.com/ , and was originally published November 1, 2005 in *The New Republic*.

to oppression." I agree, with a *caveat*. What we now call gay culture will always appeal to a certain segment of effeminate homosexual males, as it has in different forms throughout history. There will always be a small group of males who find that something resembling the gay sensibility is most in tune with who they are. The gay identity seems to work for them very well; perhaps those individuals should retain the gay identity, and they should certainly feel free to express themselves as they see fit. However, the gay sensibility is distinct and specialized; it is not directly related to the experience of homosexual desire. Being part of the gay subculture should be a matter of individual preference, not something compulsory or expected of all those who experience same-sex attractions.

Now that tolerance for homosexuality is widespread and oppression is minimal, the next step in sexual liberation is to challenge the idea that sexuality creates ethnicity—to do away with the assumption that a man who prefers men is a separate, essentially different sort of man, a *gay man*, whose sexuality determines his interests, his politics and the way he expresses his gender. The idea that same-sex-oriented men are not true men is perhaps the most deeply ingrained and most limiting prejudice they face, and it is one that the gay identity only reinforces by socially segregating men into two groups—straight and gay. The gay identity was a *Zeitgeist* and has always been a means to a social and political end. If homosexually inclined men are to truly thrive, their sexuality must be perceived as a variation in desire among men—no matter what causes it. Those men who experience a*ndrophilia* must be distinguished from those who find effeminate gay culture and the gay identity appealing. It is time to remove the *gay* qualifier for those men who have nothing in common with gays but homosexual desire. It's time we stop forcing them to call themselves *gay men* and simply allow them to be *men*.

THE STIGMA OF EFFEMINACY

In the sixth century, during his first year as emperor, Justinian I arrested Bishop Alexander of Diospolis, who was accused of homosexual acts. Alexander was viciously castrated and paraded naked through the streets as an example to those who would dare commit *stuprum cum masculis*—sex with men. Many others followed; castration and public humiliation became the punishment of choice throughout Justinian's reign for those even *rumored* to have engaged in homosexual sex. Like many of his ideological successors, Justinian offered up these men in part to appease his angry god, Jehovah, and to deliver the emperor's domain from the fiery destruction that befell the sinful city of Sodom in the book of Genesis.[5]

While simple execution would seem to be both a satisfactory sacrifice and a powerful deterrent, the gruesome spectacle of castration is unmistakably illustrative. This particular style of human sacrifice conveys one message with grisly clarity: men who engage in sex acts with one another can no longer be men. Physical castration is literally the removal of manhood, something most men cherish perhaps even more than life itself. Many men would rather be dead than physically emasculated. In particularly macho cultures from ancient Rome to the modern Middle East, men would often prefer death even to psychological emasculation—as evidenced by Muslim outrage over the sexual humiliations perpetrated on men in Abu Ghraib. Being a man and being thought of as a man by one's male peers is deeply important to the vast majority of men; it is absolutely fundamental to their identities. Maleness is innate, but a sense of manhood is earned and proved throughout a man's life.

Manhood is a point of pride, even for men who are not especially masculine. I've observed a questioning of manhood evoke visceral, nearly violent responses among overtly effeminate men, even drag queens. In *Madame Satã*, a 2002 film about a famous Brazilian queen, the protagonist reacts tellingly to an

[5] Greenberg, Crompton

insult. He angrily proclaims, "I am a queen but that does not make me less of a man...I choose to be a queen!" That revealing scene was all too familiar to me; I'd seen it play out before my eyes more than once among queens in bars and nightclubs. Males may make light of *their own* masculinity, but exclusion from the ranks of men, when verbalized by someone else in a negative context, will incite a primal anger. *Them's fightin' words.*

Physical castration has been a recurring theme in the punishment of homosexual acts between men. Castration of men for homosexual offenses was common not just in the Byzantine Empire, but also in Visigothic Spain[6] and Renaissance Italy.[7] A thirteenth-century French code punished a first offense with removal of the testicles, and the second with removal of the penis itself.[8] In the Netherlands, one secular code offered the convicted sodomite a choice between being burned, buried alive, or forced to castrate *himself*.[9] The *choice* to accept castration as a punishment and, later, a cure for homosexual activity is especially interesting. Presumably building on the perception of homosexual desire as a medical problem, Nazis sometimes offered prisoners accused of homosexuality a choice between castration and execution.[10] The Nazis were not alone in this practice; physical or chemical castration as curatives for sexual deviance continue to be sporadically discussed, and are still occasionally employed, in the Western world.

While castration is extreme, the same message resonates throughout Western culture to this day: males who engage in homosexual acts can't be men; men who love men must be neutralized by having their manhood removed; they must become *something else*.

Effeminates have been poorly regarded, if not penalized, in

6 Greenberg
7 Crompton
8 Crompton
9 Crompton
10 United States Holocaust Memorial Museum, Holocaust Encyclopedia- "Persecution of Homosexuals in the Third Reich" (http://www.ushmm.org/wlc/en/, accessed 4/23/06)

almost every society throughout history—for obvious reasons. The most obvious is that women have also been poorly regarded in most societies. Womanly interests, fairly or not, were thought to be superficial, even childlike. But men who acted like women were also believed to be constitutionally weaker and generally less able to do the things required of them. This assessment was probably accurate. While there are fewer reasons to actively discourage effeminacy in today's overpopulated bureaucracies, where women and men often do the same jobs, preindustrial societies desperately needed their men to be manly. Work hasn't always been done at a keyboard; strenuous physical labor was necessary for survival. Populations also needed their men to protect them from *other men*—and they still do. A society of women and effeminates is highly vulnerable. Being a man has traditionally required hard work, courage, and personal sacrifice. It is easy to see how effeminacy could be considered an attempt at shirking responsibility, much like Corporal Max Klinger on the old *M*A*S*H* television series, who dressed like a woman as a ruse as an attempt to get out of the military. Cultural codes of masculinity are often linked to a sense of honor and responsibility—of pride in manhood—and a man who behaves in a womanly fashion may be perceived to be making light of what men do, or of what it means to be a man. When modern men react negatively to effeminacy, they sometimes seem to be insulted—as if to say: "being a man is *hard*; I have to play by the rules, and so should *he*." One can only imagine how much more insulting effeminacy might have seemed to men in previous ages, when being a man was so much *harder*.

Successful cultures have often made room for effeminates. Men who today might be considered transsexuals or extremely effeminate gays have been enjoyed by other men in brothels or even revered as priests or shamans. (It is notable, however, that these latter revered roles were often contingent on castration.) Effeminate men have always played an important role in the arts. In the twentieth century, many effeminate men carved out niches for themselves according to their interests and talents,

and they have unquestionably played a significant role in shaping contemporary culture. I don't advocate poor treatment of effeminates. However, I also don't think it's realistic or desirable to expect everyone to embrace effeminacy or effeminate culture if it is not to their taste. Just as I see nothing inherently wrong with being effeminate, if that is one's true nature and not mere affectation, I see nothing wrong with disliking effeminacy or gay culture. I see this as a matter of taste, not always as a manifestation of some internalized or externalized 'homophobia,' as it is often portrayed by gays attempting to shame those who don't find them as amusing as they find themselves.

The problem is that homosexuality and effeminacy are virtually synonymous in the modern public's mind. All men who love men are stigmatized as being intrinsically effeminate. Men who engage in homosexual sex are expected to embrace gay culture and are believed, especially by other homosexuals, to be 'girls on the inside'—no matter how they look and behave, or what their interests may be. As I mentioned above, a sense of manhood is important to most men. Yet, simply by acknowledging same-sex desire, men are expected to relinquish their manhood. They must submit to psychological castration. While this may seem like no great loss to effeminate men who never put much stock in manhood, what of those who *do* hold masculinity in high regard? What of those *androphiles* who love men and love being men, for whom masculinity is a thing of beauty and value? I don't love men because I see myself as girlish; I love men because I've developed a deep-seated appreciation for men and for masculinity itself. Men fascinate and inspire me. I love them in their finest moments, but also in the midst of struggle. Just watching men is a pleasure; I see in them innumerable qualities that women often fail to appreciate. I appreciate these things precisely because I am a man, because their masculinity is a reflection of my own. And yet, for this, in some perverse twist of reason, I must give up my own manhood? For this, I am regarded as effeminate and expected to entertain myself with girly things? Fuck that.

Why must this be so? Is there some proof that the experience of *androphilia* reveals me to be innately less a man than any heterosexual man? Hardly. I've met many like myself over the years who were perceivably as masculine as your average straight guy, and who were disgusted with this stigma of effeminacy placed on all same-sex-oriented men. I've observed girly ticks in straight men who were otherwise highly masculine. And I've met heterosexual men who were quite a bit more effeminate than many homos. Yet these effeminate heteros rarely have their manhood called into question, by sheer virtue of their heterosexuality. All of these men are routinely given the benefit of the doubt—their effeminate behaviors dismissed as mere quirks of character. Admit homosexuality, however, and every momentary lapse in machismo is regarded as a sure sign of a womanly nature.[11]

In part, this stigma of effeminacy has to do with a rather simplistic, polarized understanding of sexuality. Sex between male and female is nature's norm, so according to a basic line of reasoning, males who want other males must somehow be more womanlike. It's easy to see how this would make sense to people whose understanding of sexuality is grounded in that binary system of male/female. If those men who love men are really more like women, everything falls into the predictable pattern.

But homosexuality really isn't that simple. This polar understanding of sexuality is inconsistent with my own experience of attraction to men. I experience *androphilia* not as an attraction to some alien opposite, but as an attraction to variations in sameness. Genet described sex between men in terms of 'mirror' images.[12] No matter how exotic or seemingly different another man is, there's always some reflection of self

11 Indeed, I'm well aware that by writing this, my own behavior will be placed under a microscope, with queens and straights alike looking for 'evidence' that, as one fellow already put it, I'm secretly the "faggiest fagola in fagtown."

12 Genet, Jean. *Querelle.* - "It seemed to him that he was pressing his face against a mirror and that his tongue was excavating the inside of a statue's granite head."

in another male. There's always some fraternal familiarity, some common experience of maleness, some mutual understanding between men. I recently came across an article in *Field & Stream* that described all men as being "as alike as eggs."[13] While I doubt the author had sex between men in mind, in some sense it applies. There is always some polarity between two unique individuals, with one man usually more dominant than the other in most sexual transactions and relationships, but the polarity is usually far less extreme than in heterosexual exchange. Women are more alien to men, and vice versa. Men are less mysterious to each other. The dynamic between men and women is frequently described as Mars/Venus; sex between two adult men is closer to Mars/Mars. It is this Mars/Mars dynamic that is appealing to me. It's what I *seek out* in men—not some clumsy approximation of heterosexual polarity. This affinity for the Mars/Mars dynamic is essential to *androphilia*.

However, in the context of a heterosexual society bent on sexual polarity, it is easy to see how the experience of homosexual attraction prompts the question: "How can I *be* what I desire?" It is my suspicion that the vast majority of psychological and gender-identity crises experienced by men with homosexual proclivities result from that simple question. When we are all taught that love and sexual desire involve appreciation for the *opposite* sex, for sexual otherness, it is perplexing for many to experience desire for the same sex. To put themselves in a more culturally familiar context, homosexual males often construct otherness where it does not otherwise exist. A psychic separation is created between the self and the object of sexual desire. It is really no wonder that so many self-identified homosexuals, in some way perceive themselves to be more feminine than the masculine men that they desire. It seems like a psychological reflex to assume that, when appreciating the masculinity of another man, one is somehow different from him and those like him. But this is more a matter of perception than reality.

13 Heavey, Bill. "The Fat Man – In Hunting Camp, Size Does Matter." *Field & Stream.*(online) http://www.fieldandstream.com/

Perceptions about the relationship between homosexual desire and masculinity have changed dramatically from culture to culture throughout history. Cultural perceptions regarding same-sex desire and masculinity have dictated the social and sexual roles men could play, the lives they could lead, who they could *be*. While the objective reality seems to be that masculinity varies from male to male, almost regardless of sexuality, subjective realities based on public and private perceptions have dramatically influenced what it means to be an adult male who loves men. People assign meaning to sexual desire, including their own, and this meaning plays a role in shaping their personalities and dictates who and what they believe they can be.

If a culture stigmatizes male homosexuals as being innately effeminate—or promotes effeminacy in them, as gay culture does—when that stigma is coupled with a polarized understanding of sexual desire, it only makes sense that most homosexuals will think of themselves as more effeminate, as something *other* than men. Even still, many, like myself, simply *don't* feel that way at all, but are still limited and burdened by having to constantly disprove the expectations of others. If men who love men are truly to thrive, perceptions about masculinity and male homosexual desire must change to accommodate and encourage masculinity in those homosexual men who have masculine tendencies. To illustrate how malleable perceptions about masculinity and male homosexual desire are, it makes sense to examine how those perceptions have varied over the ages.

The ancient Greeks and Romans differentiated between masculinity and effeminacy in men by what sexual role they played. It is well known that the Greeks institutionalized homosexuality between men and adolescents. However, that relationship was at least partially a mentoring one, and it was so formalized, so culturally specific, and so essentially different from the dynamic between adult men that it is out of place here. Relations between adult men in Greek society were only tolerated in accordance with strict guidelines. Sex with women

was a necessity; it was considered the duty of every male citizen to take a wife and produce more Greeks. While sex with female prostitutes was prevalent, so was sex with male prostitutes. Male prostitutes and kept men played an exclusively passive sexual role, and were regarded as women to the extent that if an adult male was proven to be either, he stood to lose his right to participate in affairs of state.[14] Men who topped these male prostitutes, however, suffered no loss of either status or perceived masculinity.

This was doubly true for the Romans; sex in ancient Rome was all about power. Roman men were free to assert their manhood by sexually dominating those within the sphere of their control: women and slaves. Taking the active role with either a male or female partner was a display of virility and authority. Bottoming, however, was regarded as servile and womanly; a freeborn Roman who was known to have a taste for sexual passivity was regarded as passive by nature and, again, stood to lose his social privileges. In both cultures, an adult male who 'took it like a woman' essentially *became* a woman. This distinction was also made, albeit in a more clandestine way, among American men in the late nineteenth and early twentieth centuries, when effeminate 'fairies' routinely courted masculine 'rough trade'—apparently regular Joes who exclusively played the active sexual role and retained their masculine identities.

However, roles tend to be much more fluid among *androphiles* today. While people certainly have their preferences, most homos are at least somewhat versatile sexually. They experience and enjoy both sexual dominance and sexual submission to a varied extent. Does a propensity for sexual submission truly indicate a passive, womanly nature? It doesn't seem so. Many wealthy men who wield power effectively in the business world find release in hiring dominatrixes. I've known of many straight men who enjoy being sexually dominated by their female partners, often involving some sort of anal play. There is also a long-standing joke, apparently based partly in fact, that U.S. Marines—arguably

14 Cantarella

the most masculine-seeming bunch in the military—tend to prefer a passive role in homosexual encounters.[15]

Increasingly, I've found homo porn in which the bottom 'takes it like a man'—instead of like a moaning nymphomaniac, which used to be the norm. Indeed, if one simply listens to these videos, they sound a bit like two loud jocks pumping iron at the gym. Perhaps readily available modern lubricants that make anal sex less painful have played a role in making it less like 'making someone your bitch' and more like a friendly 'sport fuck.'

Many straight men I've talked to about this get homosexual desire mixed up with a yearning for anal penetration, and this seems to reflect some ancient attitudes. The reality is that anal sex is an adaptation; the sex follows from wanting to be with another man. It is rarely the desire to 'take it like a woman' that initially drives men to seek each other out. Anal sex is, at least initially, an accommodation that facilitates just one mode of sex between men. You can hardly blame a fella for liking it a bit. Having a healthy appreciation for one's prostate gland is not, in itself, indicative of a feminine nature. Sex between men doesn't have to be viewed according to the male/female polarities; it can be seen as an exchange of masculinity wherein both participants remain men. It is also important to note that most sexual interactions between men do not result in fucking. In fact, many *don't*. As Mark Simpson put it, "At its most basic, most 'rudimentary,' male 'homosexuality' is nothing more than a shared wank."[16] Every man loves his own cock; is it really that much of a stretch to enjoy someone else's? That hardly indicates effeminacy. Women actually tend to be a bit squeamish about cocks. It's men who *really* appreciate them.

The role a man plays during sex, or whom he has sex with, are poor ways to gauge his masculinity. Guys who have sex with women are accorded their position in the hierarchy of men by

[15] For more on this, see Steven Zeeland's entertaining *The Masculine Marine*.

[16] Mark Simpson. "Curiouser and curiouser." http://www.marksimpson.com/ (February 15, 2006)

their actions and behaviors; what a man *does* outside of the bedroom is a far better measure of his masculinity. Based on their actions, some of the men who preferred men were still regarded as men by their peers and by history. Homos just have to work exponentially harder to disprove the womanly stereotype. Taking on the role of warrior, in particular, seems to put questions about one's masculinity to rest.

The most famous examples of warrior homos from ancient culture are the mythical Achilles and his boyfriend[17] Patroclus, whom many Greeks believed had an *androphilic* relationship— or a traditional *ephebophilic* relationship that extended into manhood. Alexander the Great had a similar relationship with fellow warrior Hephaestion, and the two imagined themselves to be the living counterparts to Achilles and Patroclus. Plutarch famously wrote of the Sacred Band of Thebes, composed of 150 male couples:

> For men of the same tribe or family little value one another when dangers press; but a band cemented by friendship grounded upon love, is never to be broken, and invincible; since the lovers, ashamed to be base in sight of their beloved, and the beloved before their lovers, willingly rush into danger for the relief of one another. […] It is stated that it was never beaten till the battle of Chaeronea: and when Phillip, after the fight, took a view of the slain, and came to the place where the three hundred that fought his phalanx lay dead together, he wondered, and understanding that it was the band of lovers, he shed tears and said, "Perish any man who suspects that these men either did or suffered any thing that was base."[18]

It is easy to over-romanticize the Sacred Band of Thebes, and

17 In antiquity, it was believed that the relationship between Achilles and Patroclus was a sexual/love bond. Of course, in Wolfgang Petersen's *Troy* (2004), they were 'cousins.'
18 (B.R. Burg) Plutarch. *Lives,* "Pelopidas."

many have, but it is impossible to know for certain exactly what these men were like. While the concept for the army likely grew out of Greek pederastic traditions, it is hard to imagine a fierce army made up of men in their late 20s and early teens. To maintain such a force, one would think that many of the couples were both adults. Regardless, it is certain that Plutarch wasn't talking about a bunch of sissies. The Sacred Band serves as a dramatic and inspiring example of how noble and productive love between men can be when masculinity is not in question, but rather, is encouraged and allowed to flourish.

Hadrian, Roman emperor from 117–138 CE, kept young male lovers according to the Greek tradition, and is regarded as one of the 'better' late-pagan emperors of Rome. Even Julius Caesar is believed to have possibly played a passive role in sexual encounters with men, especially in his youth, but his accomplishments as a warrior and as a ruler made his masculinity unquestionable. The most comparable later counterpart to these men might be Frederick the Great—who likely preferred men and was an accomplished, masculine military leader.[19] Other, less-renowned modern examples abound—from high-ranking Nazis to a whole generation of men who accommodated each other during World War II. Many men who love men continue to serve in the military, regardless of the American "Don't ask, don't tell" policy. Are they simply pansies in fatigues? Hardly. Author Steven Zeeland interviewed many of them throughout the 1990s, and almost all placed a high value on masculinity in themselves and other men.[20]

In the East, things played out a bit differently. A pederastic mode of relations between men was common; emperors and officials in China had their young male court favorites, but male couples of similar age were also accepted, so long as they married women, reproduced and continued the cult of ancestor worship so important in Chinese culture. While many courtiers

19 King of Prussia from 1740–1786. (Crompton)
20 Zeeland specializes in interviews with homosexual men in the military. See his *The Masculine Marine* and *Sailors and Sexual Identity*, among others.

and favorites were no doubt rather femmy, many—in contrast to their female counterparts—also stood to gain significant wealth and power to wield on their own, regardless of what sexual role they played. They were clearly treated like men. During the Ming Dynasty, in the southern province of Fujian, male couples often cohabitated. These bonds were prevalent enough there that throughout China they were referred to as *nanfeng*—a play on the word *nan*, which means both *male* and *south*. Li Yu's titillating pornographic classic *The Carnal Prayer Mat* contains several sex scenes between its rakish antihero and other men, and there is no implication in the text that any of the participants are 'like women' for engaging in such acts.

The more even-handed cultural response to homosexuality throughout Chinese history was in part a result of the relatively relaxed and celebratory approach to sexuality inherent in the two most prevalent religions in China. Taoism, concerned with the balance of *Yin* (female) and *Yang* (male) energies in the body, was fairly liberal with regard to human sexuality. Taoists were concerned about depletion of a man's *yang* through overindulgence in sex with women, so to allow for balanced sexual interaction, they developed *yang* retention techniques to avoid ejaculation during orgasm. Because no *yin* was absorbed from the female during homosexual relations, sex between men was essentially a neutral exchange of masculine energy. This is also very much the way I see it—as a nonpolar exchange between men, where neither party is, effectively, 'the girl.' Confucianism, however, was the dominant religion throughout most of China's long history, and its morality emphasized duty and subordination to authority. Confucius said that sex was as natural as eating, but homosexual sex was considered a minor offense in Confucianism, mainly because it did not serve society by producing more Confucians. As in Greek culture, however, women were lowly regarded and expected to be utterly servile, which likely made congress with men more attractive to many.

The militant shoguns who ruled feudal Japan, like the Chinese emperors, had no shortage of male court favorites. At

least half of the shoguns who ruled Japan from 1338 to 1837 had documented affairs with men.[21] Tokugawa Tsunayoshi had as many as 130 male favorites during his reign; one lifelong companion became his chief minister. Indeed, many of these bonds resulted in the elevation of paupers and performers to lordship. Critics of these affairs disapproved not of the homosexual relationships themselves, but rather of the mixing of classes. Sometimes, romantic rivalries between rulers—as opposed to the bloodthirsty religious fervor occurring simultaneously in the West—were responsible for bringing homosexual affairs to tragic ends. Shogun Tokugawa Hidetada ordered a lover to commit ritual *seppuku* because he indulged in an affair with another feudal lord. But many of these men who courted men of authority were given domains of their own, and became rulers in their own right, which would have been unthinkable had they been regarded as women.

'Older brother/younger brother' or 'teacher/student' pairings were common among Buddhist monks; this dynamic was referred to as *wakashudō*. These affairs were celebrated positively and without undue feminization for centuries in Japanese poetry and erotic artwork. Some of these men were no doubt effete, and some were not. Zen Buddhism, imported from China in 1236 CE, seemingly carried with it some philosophical conflicts with regard to homosexual relations, but *wakashudō* was already so popular among monks of other sects that the third precept, requiring Buddhists to abstain from 'going the wrong way' sexually, seems to have been ignored or interpreted liberally. The Zen discipline was especially attractive to Samurai, whose apprentices were often the objects of *wakashudō*. Much like the famed Greek warriors of Thebes, the Samurai and their male sex partners (*gomotsu*) idealized honor and courage; they often fought together to the death. In modern America, where homosexuals are regarded by many as being too womanlike to be allowed to serve in the military, this hypermasculine mode of homosexual desire may seem somewhat alien. Yet, the very

21 Crompton

existence of such a culture calls popular assumptions about the innate femininity of homosexual men into question.

This is a manifesto; it is not meant to be a history text. What I'm presenting here is selective, relevant history. I encourage anyone interested in the history of homosexuality to go to my sources. What is clear from any objective history of homosexuality is that there have been both effeminate same-sex-oriented men and those who were quite masculine. Why, then, do so many people insist on lumping homosexual men into one group, attributing a feminine nature to all of them?

As previously mentioned, the Greeks and Romans regarded homosexuals as effeminate based on what sexual role they played, who they had sex with, and to a lesser extent, their overall behavior. As Christianity gained popularity in the Roman world, however, Old Testament prohibitions on all homosexual activity, regardless of role, became more widespread. Christian rulers initially made penalties for passive, effete homosexuals harsher, but eventually extended these penalties to all those who engaged in homosexual acts. Which brings us back to Justinian, who made certain that all those caught engaging in homosexual acts were penalized, regardless of their sexual role or their behavior. Men who preferred men became, in people's minds, one group, who were all subject to the same punishment—in many instances, the removal of their manhood. As the law stopped differentiating between homosexuals, it is easy to see how over time the stigma of effeminacy, once reserved for passive homos or the obviously effete, was attributed to all homosexuals. Guilty of the same vice, homosexuals were all associated with the same characteristics. Though, to be clear, this association was not always made. Active adult male homos were sometimes seen as more predatory than effeminate, probably because they followed the pederastic model of homosexuality and seduced significantly younger males. The key point here is that early Christians stopped distinguishing between types of homosexuals, and grouped them all together.

Christians throughout the West repeated the trend-setting

acts of Justinian with vigor and flourish for centuries. That which motivated Justinian also influenced the Inquisition, which in Spain sometimes burned more 'sodomites' than heretics. Everything from plagues to floods to failed wars could be conveniently blamed on the existence of 'sodomites,' who were ritually sacrificed to ensure the good favor of Jehovah— often with a pomp and theatricality that might have inspired envy among the Aztecs, had they not also been trampled by Christians. This primitive culture of supernatural fear is still alive and well; the anti-homo rhetoric of today's hysterical televangelists is remarkably similar to the rhetoric used to justify the purges and executions of sodomites hundreds of years ago.

Most working-class men with homosexual tendencies during the Middle Ages and the Renaissance likely married, raised children and confined their relations with men to a few isolated trysts. Those caught *in flagrante delicto* were tortured, maimed or killed. Clandestine coteries of intellectual men who preferred the company of other men existed occasionally, but the stake always loomed. When such transgressors were legally untouchable—as with monarchs, favored generals and members of privileged aristocracies—psychological castration was employed. Critics in the know were swift to portray even the most calculating rulers and virile military men as superficial prancing pansies once their inclinations became known. The ancient association of weakness and effeminacy with homosexual passivity never faded from the popular imagination in the West. As all sodomites, since the age of Justinian, were considered to be a similar lot, all were equally abominable, equally feminine and equally impotent. Despite appeals to divine and natural law, for Westerners adult male homosexuality remained an offense against manhood. Those who transgressed against cultural codes of masculinity that forbade homosexuality often had their masculinity stripped away in a final public shaming. Those who others imagined did not carry the mantle of manhood with due reverence were made as women before all.

In the nineteenth century, as science and reason competed

with religious superstition in public discourse, homosexuals known as *uranists* sought to advance their cause by appropriating the stigma of effeminacy; they argued that they were never really 'real men' to begin with. To gain public favor, rather than portraying themselves as men who simply preferred men, they portrayed themselves as *something else*. In effect, they castrated themselves.

The *urning* theory of homosexuality was conceptually devised in 1852 by Ludwig Casper, who suggested that preference for homosexual sex was an inborn trait that suggested a 'hermaphrodism of the soul.' Around 1864, lawyer Karl Heinrich Ulrichs published brochures in which he coined the term *urning*, drawing from a mention in Plato's *Symposium*, which seems to suggest the goddess Aphrodite Urania was a patron of 'noble' homosexual love. It was believed that Aphrodite Urania was born directly from Uranus (Greek god of the sky), which distinguished her from the more common Aphrodite Pandemos, born of a man (Zeus) and a woman (Dione). As such, Aphrodite Urania represented high or spiritual loves, whereas Aphrodite Pandemos was associated with earthly lusts between a man and a woman. It is perhaps telling that Ulrichs selected Aphrodite Urania to represent his concept of the *urning*: while Aphrodite Urania maintains a connotation of nobility in sentiment, she is still fundamentally a female who sprang forth from a male. It's the perfect gay-stereotype image—a woman that springs forth from a male, like a drag queen.

Ulrichs' *urning* was not a true man, but rather a man with a woman's soul. He was supposedly unable to copulate with women, and it was his nature (as someone who was a woman on the inside) to seek out the male body. The argument then followed that if *uranism* was his inborn nature—if he didn't have a *choice*—then it was indeed cruel to punish him for acts in accordance with this nature. In the post-Enlightenment atmosphere of the nineteenth century, the reform of oppressive moral and legal systems was possible, so long as convincing arguments were made in the interests of reason and the greater good. Ulrichs' assertion, one

that would have delivered him to the stake a century or so before, now evoked some public sympathy. The homosexual man was no longer a man with unusual tastes, but a different breed of person altogether. A fair and rational society, it was theorized during the Enlightenment, should not punish or ostracize a person simply for being born 'different.' Does this sound familiar? It should, because it is the favored rationale of The Gay Party today, despite the fact that in the course of the century-and-a-half that followed, scientific evidence to back this theory remains spotty and inconclusive at best.

Magnus Hirschfeld, who could be called the father of the modern Gay Rights Movement (though the term *gay* was not adopted by homophile activists until many years later, in America), also realized the political potential of this position. As a doctor, he set about proving the theory by 'studying' known homosexuals and eventually became known as something of an expert on *uranism*; he was often called to testify in legal hearings when suspicion of homosexuality was involved in a case. He made the theory of *uranism* the central argument of his campaign against Paragraph 175, the portion of the German criminal code that criminalized homosexuality. Hirschfeld very nearly achieved victory, though his progress was stifled as Nazi influence in Germany grew. However, due to his influence, many medical professionals began to consider the theory of *uranism*. The groundwork was laid for the acceptance of both the notion that homosexuality is an innate natural affliction, and the notion that a man who experiences same-sex desire is a distinctly different sort of man—a man who is a woman inside, from the moment of his birth.

Hirschfeld's ideas were not without their detractors, even among men with homosexual tastes. Adolf Brand, initially a supporter of Hirschfeld's organization, the Scientific Humanitarian Committee, took a marked dislike to Hirschfeld's key strategy—medicalizing homosexuality and advancing the emasculating theory of *uranism*. Brand and his associates instead took a more principled, rather than pragmatic, position.

In Brand's trailblazing magazine *Der Eigene*, writers denounced the theory of *uranism* and railed against the religious asceticism that was the cause of antisodomy laws in the first place. *Der Eigene* was often heralded as a journal for 'male culture.'

Brand considered both pederastic and *androphilic* homosexual relations to be healthy and socially constructive forms of male bonding. For Brand, homosexuality was a wholesome expression of masculinity among men who may or may not choose to marry women at some point in their lives. In stark contrast to the 'subspecies' of male women put forth by the *uranists*, Brand's homosexuals were simply men who celebrated masculinity and who preferred the company of (and, ostensibly, sex with) other males.

Unfortunately, Hirschfeld had dubious science on his side, and the more culturally focused Brand has been written off as a radical fanatic, a pederast, or a misogynist. He was probably all of the above, but his example proves that, even at the birth of the movement for sexual freedom, there were homosexual men who did not consider themselves to be fundamentally different from other men, and who abhorred the idea that they were 'hermaphrodites of the soul.' I've read Brand's work, and I don't agree with all of his ideas. But in challenging the idea that homosexual desire automatically makes males *something else*, that it makes them intrinsically less masculine than their heterosexual counterparts, and by championing male culture, this manifesto is very much an echo of Brand's initial dissent.

The strategies employed by Dr. Hirschfeld and the *uranists* were significantly developed by homophile activists throughout the twentieth century. While it is notable that many of the early gay activists in the 1960s and 1970s[22] followed Alfred Kinsey's model, wherein almost everyone is more or less bisexual, gay advocates in the 1980s and 1990s reverted to Hirschfeld's strategy and pressed the idea that all those who engaged in homosexual acts were 'born that way,' and gays must be considered a special minority group. The gay activists and supporters of The Gay Party

22 See specifically Carl Whittman's *Gay Manifesto*, circa 1970.

line in the twenty-first century are the direct heirs of the *uranists*. The new *uranists*, bolstered by the success of other struggling minorities, continue to scramble, as Hirschfeld and others did before them, for medical evidence to validate their claims. They have created an artificial division between men and 'gays,' who are *something else*—a race of men who are not-quite-men: *gay men*. These *gay men* have appropriated the stigma of effeminacy; and routinely socialize each other to 'be more *gay*' because they believe that this is what homosexual desire implies in men. After the onslaught of AIDS, the Tom-of-Finlandesque subcultures of butch gays never quite regained the social prominence they had in the 1970s, though both nostalgic scenes and new mutations that embrace masculine homosexuality currently exist. Gay advocacy and gay culture today are dominated by feminists and shrill male women. To accept homosexuality in oneself is now equated with accepting an intrinsic effeminacy, and any denial of this is widely believed to be symptomatic of 'internalized homophobia.' On some level, the gay mainstream still regards homosexuals as 'hermaphrodites of the soul'—no matter how masculine they may be in behavior or appearance. Effeminate gays still take great pleasure in referring to masculine homos with female pronouns.

The real 'internalized homophobia' is the belief that you can't truly be a man simply because you love other men. Over the course of history, psychological and physical castration have been the most powerful weapons of those who despised homosexuality. Institutionalizing the idea that all homosexual men are fundamentally different from other men, and fundamentally less masculine, essentially says that, on one level, those homophobes are right. Gay advocates argue that they are 'second-class citizens,' but they seem to have no problem with being 'second-class men.'

While the modern Gay Rights Movement has secured a comfortable level of liberation for those with same-sex preferences, gays made a Faustian bargain in trading away the masculinity of all homosexual men to get there. Rather than

acknowledging that there are and have always been homosexual men who are masculine as well those who are feminine, and differentiating between the two, latter-day *uranists* gathered all same-sex-oriented men under the effete gay rainbow banner. Instead of challenging the ancient stigma of effeminacy once only attributed to men who played the sexually passive role, modern gays embraced that stigma and applied it to *all* men who engage in homosexual acts.

By creating a separate, ghettoized gay culture characterized by overt and affected effeminacy, and immersing themselves in it, gays have effectively constructed a cultural barrier between themselves and other men. By identifying themselves as *gay men*, homos perpetuate the idea that they are a dramatically different sort of male, a male who is constitutionally less manly, a male who is deficient or inferior to the straight male. The gay identity is so powerful because the gay community invited those who were outcast, who were stigmatized as being different, to accept that difference and see it as something that makes them special and should inspire self-worth. What I am doing here is questioning the idea that they were ever really all that different in the first place.

Instead of liberating homosexual men from the stigma of effeminacy, gays, in concert with feminists threatened by masculinity, simply made effeminacy more acceptable. Since many die-hard effeminates are ambivalent about masculinity at best, and because they think effeminacy is absolutely fabulous, it is easy to see why they wouldn't be overly bothered by this. Many gays truly *like* the idea that they are not quite the same as men, and imagine themselves to naturally possess all of the best attributes of both sexes. Perhaps, because of this, they figure it's not their concern, and that anyone who values masculinity and who is uncomfortable with the stigma of effeminacy ought to speak for himself.

So I am.

'MAN'—THE NATURAL RELIGION OF MEN

I've spent a great deal of time talking about masculinity so far—who hates it, who likes it, who is masculine and who is not. But what is it? To an extent, masculinity is universally understood. While many would discuss it as if it were nebulous or undefinable, and a survey would likely gather a wide range of answers, everyone reading this can differentiate between men who are masculine and those who are less so. We can quibble over what makes a guy manly, but it's not as obscure as it is sometimes made out to be. It is also less extreme than it's made out to be. The first examples of masculine men that come to mind might be cops or soldiers or athletes. But I just took my morning walk to the store, and while I saw masculinity embodied in the construction worker purposefully grabbing tools out of his truck, I also recognized masculinity in the grocery-store shift manager and some kid barely out of school.

People reach for those extreme examples of manliness because masculinity is not just a quality shared by many men, but also an ideal to which men collectively aspire. Masculinity is a religion, one that naturally resonates with the condition of maleness. Worship takes place at sports arenas, during action films, in adventure novels and history books, in frat houses, in hunting lodges. If there's nothing essentially different about men and women, why are so many men drawn to these things? Why do men find these things so satisfying?

Steven E. Rhoads recounted an illustrative story in his *Taking Sex Differences Seriously* about a peace-loving Berkeley feminist struggling to raise a peace-loving 3-year-old son. Her problem was that he was fascinated with guns and naturally gravitated to them, even ingeniously manufacturing them in their absence, despite his young age and upbringing in a household where the only thing on television was *Sesame Street*. It was no surprise to me when, some time after reading this, I came across an article in the *New York Times* citing a study that linked the handling of guns to a spike in testosterone levels in

men.[23] Another widely cited study has shown that sports fans experience a 15 to 20 percent increase in testosterone when their team wins.[24] There are other studies that have recorded similar relationships between traditionally masculine behaviors and chemical changes in the male body. I'd be willing to bet that researchers could find chemical changes in men or boys after roughhousing, fighting, building something with a hammer and nails, lifting more weight at the gym, unloading a truck, or any number of other activities associated with manliness. I say this because I've personally noticed a certain male exhilaration and satisfaction, a physical sensation of masculinity that seems to stem beyond mere psychological gratification when actively engaged in these things.

There's something to this 'being a man' business. It's not just some completely constructed social identity, as many gays and feminists believe. The things that men like, the behaviors that resonate with them, and idealized masculinity are physically part of being born male. Where ideals of masculinity are absent, men seem to create them in much the same way that they seem to spontaneously create religion. While the specific behaviors and ideals of masculinity change somewhat, sometimes greatly, from culture to culture, there is a distinct cross-cultural commonality in what it means to be masculine. Social constructionists often like to find some rare exception to the rule to invalidate this, but I'm just not the type of guy who believes rare exceptions really invalidate obvious truths. Just as I said almost anyone reading this could identify a particularly masculine man if they were given a range of men and asked to do so, I believe you could do this easily among any culture that has ever existed, and that the man chosen would be generally regarded as masculine by his peers—assuming there wasn't some transgression of a culturally specific masculine code in his past unknowable to you. This is

23 Carey, Benedict. "In Men, 'Trigger-Happy' May Be A Hormonal Impulse." *New York Times*. May 9, 2006.
24 Fielden, J., C. Lutter, and J. Dabbs. 1994. "Basking in glory: Testosterone changes in World Cup soccer fans." Psychology Department. Georgia State University.

why I refer to masculinity as the natural religion of men; the concept of manliness doesn't just come out of nowhere—it grows naturally from the physical experience of maleness. What differs from culture to culture is the way in which men develop this religion.

To discuss masculinity effectively, I've found it helps to separate it into three different aspects: **physical masculinity**, **essential masculinity**, and **cultural masculinity**. All three have a complex relationship with one another.

Physical Masculinity

Physical masculinity is simple but by no means completely understood by science. At its most basic, it is sex—the physicality of being male. It includes both primary and secondary sex characteristics, from simply being born with a penis to being physically stronger than females and usually having different body-hair patterns. But there is more to it than that. I've already touched on the fact that men are hormonally different from women; this must have a significant impact on their behaviors and the way they experience things. There is some evidence that men as a whole have significantly different brain structures and natural aptitudes. Their senses are different. They see and perceive the world differently. All of these things are part of being male, and while scientists have found *some* differences among *some* men who prefer men, my position is that homosexual and bisexual males are still far more male in the way they experience the world than they are female.

Essential Masculinity

The body informs the mind. It is the physical experience of maleness that engenders *essential masculinity*. Men, because of their physical experience of maleness, tend to be more naturally aggressive or assertive. Males tend to respond to certain things in harmony with their bodies. But these responses are not isolated incidents, as they appear when we look at scientific studies. These responses occur over a lifetime and have a cumulative effect.

They shape personality in a profound way. From the time males are born they inhabit a male body and the way in which that body responds to the world around them has an effect on their psychology that's at least as meaningful as social conditioning. The state of maleness itself, in concert with things like hormones and brain structure and male physicality, creates a distinctly male identity independent of active social conditioning.

Just the fact of being born from a woman, but being fundamentally different from her, creates the sense of a different role. For instance, a sense of being some sort of 'protector' doesn't come only from social conditioning, it develops naturally from knowing that you are physically stronger and perhaps more aggressive than your mother and/or sisters. It comes from identifying with the obviously bigger and more aggressive men around you, and less so with the women close to you—from knowing that you are destined to be more like the men. A woman's psychological identity similarly grows from the same obvious differences between the men and women around her. Gender isn't only something we are taught, it is something we see and experience on a personal level. Differences between the sexes aren't merely something a child learns, they are something a child observes and processes on his own. You can't do away with that simply by teaching children that men and women are the same. Anyone with eyes can see that they're not. Observable differences between the sexes create observable differences in psychology.

One of these differences in men is the need to establish that difference. At the most basic level, it may boil down to a question like, "If I am not one of the women, if I am not going to bear children like my mother, what am I and what role do I play? What does it mean to be male?" We all begin life as females, and grow inside females. Being male is being different; it is the first sense of being different that males usually experience—before differences like race or class are even recognizeable. As such, being male is fundamental to a man's sense of self. This is why being a man is so easily idealized; it starts out that way. It starts

with recognizing that difference and conceptualizing what that difference *means*. If you think about men who are idolized as being manly, what they have in common is that they are *most* different from the way women are perceived to be. This is why the men described as manly are the biggest, the strongest, the hairiest, the most aggressive, the toughest, the most powerful, the least sensitive and the least nurturing. Being manly is being different from women; it means exhibiting qualities opposite from those perceived in women. Do some women *also* exhibit characteristics attributed to men? Of course they do. Some are quite physically strong, some are aggressive, some are tough, some aren't especially nurturing or sensitive, some are powerful and some are even kinda hairy. But to say that *most* are would be an obvious lie. Being manly essentially means being different from the *majority* of women.

It is in establishing this difference that men do some of their most impressive work. Aggression, and its more civilized sibling assertion, are essential aspects of masculinity. The nature of masculinity is active. Being a man, in virtually every culture, requires that men 'go out and do something.' It requires that they compete and establish their manhood by winning the esteem of men, usually by triumphing over other men or women or nature. In doing these things, on some level, men are establishing their masculine identities and a sense of belonging among men. Being a man requires that you accomplish something. Women accomplish many things, especially today, but it isn't required of them to be considered women. As attractive women know well, their womanhood is affirmed, usually by men but also by women, for simply being attractive. A man may be extremely attractive, and thus considered desirable. But if he doesn't prove his manhood, instead relying on his looks, men will regard him as an impotent, narcissistic dandy. This difference in the way manhood and womanhood are perceived is easily observed in contemporary Western society, but anthropologist David D. Gilmore, who has studied cultural concepts of masculinity in various cultures, makes a similar point in his *Manhood in the Making*:

Although women, too, in any society are judged by sometimes stringent sexual standards, it is rare that their very status as woman forms part of the evaluation. Women who are found deficient or deviant according to these standards may be criticized as immoral, or they may be called unladylike or its eqivalent and subjected to appropriate sanctions, but rarely is their right to a gender identity questioned in the same public, dramatic way that it is for men.

A male might be considered manly at first glance if he simply grows a beard—evidence of physical manliness—but he won't be considered truly manly by other men unless he behaves in a certain way. A man must *do something* to earn his manhood.

This desire to *do* something, to *prove* manhood often manifests itself in raw aggression, which has been useful for men but is generally nonproductive in civilized society. Prisons are full of men who were trying to prove their manhood in some nonproductive way. Sometimes, that raw aggression is channelled by a warrior ethic; drill sergeants bring it out in their recruits and these men serve as our soldiers, as they always have. It's also channelled productively by professional athletes. But these are extreme examples. This desire to prove manhood, to actively accomplish something or triumph in some way, often manifests itself in male ambition. There are certainly ambitious females. But men are, as a whole, more *driven*, and I think this in some way reflects a very male desire to prove their manhood, to prove they are 'good for something' in a way different from women. Ambition is not exclusive to men, but it is a very male thing that comes naturally to many men. This ambition to, in some way, assert oneself has not only resulted in wars and violence, but also in the exploration of the world, our greatest works of art, our most impressive inventions, the most magnificent buildings and the most successful companies. In this way, I see masculinity not only in lumberjacks and Navy SEALs, but also in someone like Bill Gates or America's early so-called robber barons and industrialists. There's a reason why

more men than women love repeating popular slogans like "Go Big or Go Home," and "GIT-R-DONE."[25] Men prove themselves to other men through accomplishments that require sacrifice and hard work. It's expected of them to 'go big,' whether that means getting a big truck or being the first in their field to do something impressive.

This brings me to values like self-reliance and independence, which are exceedingly important to most men. Men are, at the very least, expected to carry their own weight. Manly men are leaders, whether it be in the home or the office. A man earns respect by taking charge without asking for assistance. The old but illustrative cliché about men refusing to ask for directions comes to mind. Men also often love their sports teams, but they love the standouts and stars of those teams even more; they make them into heroes and role models of manliness. Men idealize and want to be the man whom my father jokingly refers to as 'Mr. Make-It-Happen.'[26] Self-reliance and an assertive, take-charge mentality are essential to masculinity. I don't care if you're talking about executives or construction workers or composers or some isolated tribe of hunters and gatherers. Being a man means bringing home the goods, whether it means a fresh carcass or a new account. Yes, today's woman may be able to bring home the bacon *and* fry it up in a pan—but all of this is not required of her to simply be considered 'womanly.' This may change, but I doubt it, because there is still that essential difference between men and women that is not merely constructed.

Essential masculinity is characterized by *desire*. *Essential masculinity* is the *desire* which grows naturally from the physical experience of being male—the *desire* to be assertive, to exert strength, to be aggressive, to be independent, to differentiate oneself from women and to idealize manhood.

[25] "GIT-R-DONE" is attributed to Daniel Whitney, aka 'Larry The Cable Guy.' Incidentally, it's also been my personal slogan while writing this manifesto on a deadline. I tried to figure out who said "Go Big or Go Home" first, but so many people use it that I was unable to figure out who originated it. My apologies to *him*.

[26] Apologies if my father did not *actually* make this up on his own.

CULTURAL MASCULINITY

Cultural masculinity refers to the different ways in which various cultures and social groups idealize manhood. All cultures spontaneously idealize manhood; this is why I consider the *desire* to idealize manhood *essential* to the experience of maleness, as I explained above. But cultures idealize masculinity differently, based on their needs and circumstances. Cultural masculinity is malleable, but when groups associate behaviors or even garments with masculinity, they become quite meaningful, because the identity of 'man' is so fundamental to almost every man's sense of self. Many of these things stem from *essential masculinity* but are not essential by themselves. Chivalry and samurai codes of honor are examples. Others—whether or not you eat quiche or like your steaks raw—may seem completely superfluous and silly; they have no real bearing on how *essentially* masculine you are, though each will be regarded as a gauge of masculinity by many.

Cultural masculinity is extremely influential and meaningful for most men. It is this aspect of masculinity that makes it most like a religion. Or rather, an *organized* religion. *Essential masculinity* is something spiritual, a quality of the soul;[27] cultural codes of masculinity form the doctrine of the masculine religion. Because being a man is so significant to men, things successfully associated with manhood gain some of that significance. When ideologies are associated with masculinity, men are especially vulnerable to a male-specific sort of manipulation. Masculinity carries ideology like fat carries flavor. When some belief system entangles itself with what it means to be a man, the results are sometimes disastrous and other times quite inspiring. Religions, racism, and forms of nationalism are particularly volatile. When being a man means belonging to a group, that group can redefine masculinity for the men belonging to that group according to its own agenda. World War II is the obvious example, with each man—whether

27 I'm using the words *soul* and *spiritual* in a metaphorical sense, but you may take them however you like.

Communist, Nazi, Fascist, or a proponent of democracy and freedom—believing in some way that he was doing his duty as a man to fight for those beliefs. Each were heroes for their own cause, and took pride in that role. The Nazis did an especially impressive job of linking National Socialism to manhood; from their youth programs to the overtly masculine way in which they styled themselves. Fighting for a cause that offers manhood gives men an opportunity to prove their manhood, but in many cases just supporting the cause, as with sports teams, offers a prepackaged sense of collective masculinity. Many men 'prove' themselves men merely by belonging to a group or supporting a group cause. They are men because *men support the cause.* Men have traditionally loved and been admired in uniforms because uniforms advertise that belonging, that cultural association with some masculinized group. Whether we think this is good or bad in hindsight depends on what we think of the cause itself. Such is also the case with religions, many of which utilize the desire to prove manhood to their advantage; a common Christianist bumper sticker proclaims "Real Men Love Jesus." Modern Islamo-fascists make use of their culture's fusion of Islam with manhood, and incite men to terrorist and even suicidal acts to prove their masculinity.

However, societies and religions also manage to manipulate *essential masculinity* in positive ways that serve the individual, the community or both. Stewardship, responsibility, courage, honor—to 'protect and serve'—have all been integrated into cultural concepts of masculinity to the benefit of mankind. Cultures shape *essential masculinity* to fit societal and individual needs to bring out the best in men. Codes of masculinity mold boys not just into men, but productive and successful men who then mold society. Value systems can and do change over time, but when they are ignored or when destructive values become more attractive, men run amok. Urban gangs and small groups of poorly supervised teenagers demonstrate how hastily males cobble together a collective masculine ideal, when existing ideals and role models are either absent or viewed to

be impotent. Unfortunately, those ideals born from adolescent rebellion instead of thoughtful adult consideration tend to be shortsighted and destructive.

Gilmore has provided the most insightful and concise understanding I've read regarding *why* cultures develop masculine ideals, why they create this religion of manhood. He presents masculine ideals as guards against "boyishness" in men, as ideals that drive men away from "regression" into modes of behavior that revolve around nonproductive, childlike gratification:

> Regression is unacceptable not only to the individual but also to his society as a functioning mechanism, because most societies demand renunciation of escapist wishes in favor of a participating, contributing adulthood. [...] In sum, manhood imagery can be interpreted from this post-Freudian perspective as a defense against the eternal child within, against puerility, against what is sometimes called the Peter Pan complex.

The gay community, by rejecting all masculine cultural ideals, rather than only those which prohibit homosexual expression, allows its males to remain boys. Many gay men never grow past a focus on instant gratification and devil-may-care, hedonistic sensualism. The gay community promotes nonjudgmentalism and relativism, only expecting its males to accept their gay identity and find happiness by doing whatever feels good to them at any given time. Gay culture celebrates superficial pursuits like fashion and looking good, but rarely celebrates potential role models who do anything more substantive—unless they're political activists working on behalf of the gay community. By separating gay men from other men and quarantining them in a ghettoized gay culture, the gay community deprives its males of productive masculine role models. It mothers its boys according to a misguided feminist understanding of masculinity, but deprives them of father figures who will challenge them,

demand more from them, hold them to a higher standard—a masculine ideal—and inspire them to become men.

Part of the problem with many feminists and gays is that they do everything *but* play into men's need to be men. The goal of many feminists is to bring out a man's 'feminine side,' to make men more like women. They want to neutralize masculinity and make it 'safer.' But that's not what males instinctively want or truly need. They don't want to be more like women. They are males, and they want to be more like men. In a very real sense, I'd link the current popularity of conservatism to a backlash against liberal, feminist-influenced 'mothering' of men. I've even read of some lame attempts by feminists to create school discussion groups where males can get together and talk about masculinity—usually with the agenda of preventing rape. Men don't go to henhouse discussion groups to talk about their feelings about masculinity. Those who would care about these groups are probably not the ones who would commit rape. Males don't look to women or effeminate gay men for advice on how to be men. They look to other men, and if the men around them don't seem virile or manly enough, if those men aren't different enough from women, they'll look to other men when shaping their own personal codes of masculinity. The vast majority of men will always look to men who are manly, who are essentially different from women and who will help them differentiate themselves and form their male identities.

If the 'sensitive' man is really 'in,' I don't see it. I see the rise of Ultimate Fighting[28] as my generation's answer to boxing. I see urban hip-hop culture, which glorifies street violence, crime, easy money, flashy status symbols and irresponsible sex, surpassing other subcultures in terms of mainstream popularity. Instead of wanting to grow up and be cops and firemen and astronauts and soldiers, boys increasingly grow up acting like they want

28 My point here is that sports are not getting *less* violent, or 'more sensitive.' I love Ultimate Fighting and I think it may provide just the kind of positively managed hypermasculinity that young men crave.

to be 'pimps'[29]—prison-hardened 'stone cold playaz' that make the previous generation's 'sex, drugs & rock 'n' rollers' look like candy-asses. I see ever-more-violent movies and video games. I see SpikeTV and endless sports channels. Male aggression isn't going away. While today's men might be excessively mothered by institutionalized feminism and leftism, they are still seeking out father figures in especially masculine men.

Father figures and manly role models—heroes—make up a pantheon of gods for men. Men are natural hero-worshippers. These heroes are not only heroes in the traditional sense, but heroes of all sorts who exemplify masculinity in different ways. Not just warrior and John Wayne types, but Godfathers and rock stars and athletes and villains and historical figures and the guys who have achieved what men want for themselves. The natural gods of men are other men, mythic or real, who embody manhood in men's eyes. Heroes shape cultural concepts of masculinity; they give manhood personality and character. In the virtual absence of communal coming-of-age rites, and without strictly defined societal codes of masculinity, heroes play an even more central role in guiding men into manhood than they probably once did. Men worship the concept of 'man' by admiring and imitating other men. Men integrate the honor codes of their heroes into their own personal code of honor; the styles of their heroes' masculinity are integrated into the way each man expresses his own *essential masculinity*. Men are unique composites of their varied heroes—their gods of masculinity.

'Man' is a religion shared by almost all men. Manhood is fundamental to who men are; the way they conceptualize masculinity is the way they form their most basic sense of identity. This religion, through its culture, ritualizes and channels their essential and physical masculinity. Their understanding of what it means to be a man guides their behavior and forms their personal code of honor. What a man will and won't do is more often than not related to what he personally believes a man *should* or *should not* do. Masculinity in its most religious sense

29 In both the literal and 'poetic' sense of the word.

can be problematic—but it's not a problem. It's a solution. It guides boys into manhood, accomodating differences between the sexes and making use of the natural male desire to find meaning in maleness. The majority of males will always seek that meaning, they will always want to perceive themselves as being manly. Those who laugh this off, seek to render masculinity meaningless, or to make it a virtual equivalent of femininity do so at their own peril. Men will simply seek out manliness elsewhere.

For a society to get the most out its males, it has to affirm their masculinity in a productive way—not simply negate it. Its male role models—its masculine gods—must be both productive *and* manly. It must offer a cultural code of masculinity that encourages productive behavior. But it must let them be men. It must show them how to be men, or they will simply be male. And males running amok without a productive sense of what manhood means can be extremely counterproductive—for both those individuals and for society in general.

TOWARD A MASCULINE IDEAL

Homosexual males are males running amok.

The lack of universal acceptance for homosexuality is not, as it is often portrayed, the root of all ills among homosexual males. Universal acceptance for homosexuality is unattainable. But even if it were attained—if parents across the world suddenly started *hoping* their children would become homos—it wouldn't solve all of the problems that many believe it would.

Homosexual males are males who have been robbed of a masculine ideal. Most are lost boys without a sense of what it means to be men—Peter Pans who never become men and leave the never-neverland of The Gay Party life.

Homosexual males don't become men because they're never expected to, because they don't recognize themselves as 'real' men; they regard straight men as MEN and regard themselves as *something else*. Because they've been stigmatized as being effeminate, they play at being womanlike; but they're simply not female. They take female role models—powerful but often tragically self-destructive women like divas—and identify with them instead of with powerful males. They will never really become truly *like* those women. Homosexual males will always still essentially be males. And because they're males, they still demonstrate distinctly male tendencies. Fortunately, perhaps because they're expected to act like women and concern themselves with girly things, they aren't a particularly violent bunch overall. But all of that innate maleness—that aggressive, restless energy—seems to find instead an outlet in promiscuous sex, drug use, alcohol abuse and generally adolescent behavior. I'll plead the Fifth with regard to adolescent behavior, but these problems are much less prevalent among lesbians. They have *other* issues. The problems specific to the homosexual male population are the result of unchecked maleness.

It is a relatively new thing in the West to be an openly homosexual male who is free from the threat of prosecution or physical oppression and, for the most part, tolerated by society.

Because homosexual men have traditionally been beyond the pale of conventional morality, there are no codes of morality that govern them as a group. There's no ideal or model to guide their behavior. Productive male role models are virtually nonexistent. Gay icons are virtually all tortured, self-destructive artists, and most are female.

If homosexual males are going to be more productive and less self-destructive, they need more productive male role models and they need some sort of code of honor, a set of common values, a model of behavior, something they can aspire to—something that works in harmony with their essential male nature.

I know. I know homosexual males are sick to death of moral codes and social ideals. Many gays believe all codes and ideals are fundamentally oppressive, and at any rate they've long since conceded the territory of morality and social ideals to those who reject homosexuality, especially religionists. Gays view virtually any talk of ideals designed to moderate *their* beavior as homophobic and heterosexist. (They have a lot of good ideas , though, for what straight people ought to do.) The cliché 'coming-out' drama always tells the tale of a nice boy who tried desperately to meet his family or social group's ideals but who then ultimately failed, accepted his gay identity and escaped over the rainbow to pursue his new, free, gay life with the unlikely boy of his dreams. A nice fairy tale, if you're into that kind of corny stuff. However, no one really ever adequately explained why so many of these nice boys who have broken free from the slave chains of social ideals and conventional morality manage to end up addicted to drugs or suffering from sexually transmitted diseases. I believe that in part this is because the gay never-neverland is a wild, propagandist's paradise swarming with exotic bugs and unmarked pitfalls. There is no trail, and there is no guide. That may be exhilarating for a few quick-witted, fiercely independent adventurers...but most folks would fare better with some sort of map.

I'm not a particularly 'moral' guy, by the usual definition. I'm not concerned with Judeo-Christian sexual morality or

arbitrary, rigidly enforced concepts of right and wrong. I believe that what is productive for the individual is often productive for society as well. I'm interested in solutions that make sense for homosexual males, solutions that will challenge and bring out the best in them—instead of encouraging, as I believe gay culture does, their least productive tendencies.

The purpose here is to reclaim masculinity for *androphiles*, to reclaim manhood—this religion of man—and adapt it to their condition. Prohibition against homosexuality in men and the deterring stigma of effeminacy are breaking down; they're both malleable, cultural aspects of masculinity. Only the divisive gay identity itself stands in the way of homosexual males taking their rightful place beside men and truly becoming men in their own right. By perceiving themselves as men, by seeing their sexuality as a mere difference in sexual preference and dropping all of the baggage that comes with gayness, they can look to all men, straight men and homos alike, for productive models of masculinity that are compatible with their own *essential masculinity*. They can look to great men, manly men, for guidance. They can build their own personal pantheon of male gods and mold their own sense of what it means to be a man in the image of those gods, as other men do.

Many homosexual men want to think of themselves as being masculine and hold masculine ideals in high regard. But they find themselves lumped into the gay community, which sends the opposite message—to behave effeminately and reject both masculinity and masculine codes of behavior. If masculine homos do this, however, they're rejecting a part of who they really are.

By reevaluating masculinity and finding out what it means to be men, they may find a part of them has been sorely neglected. They may find fulfillment and direction and meaning in ideas and activities that are meaningful and productive for so many other men. By discovering what it means to be men and aspiring to manliness, they may find kinship with other men and earn their respect. They may find heritage in a history that is suddenly

more familiar than alien. They may find that they become more comfortable around straight men and share more in common with them than they ever imagined. They may find that other men can show them more about themselves than women ever could. They may find that embracing masculinity is better, more productive for them than rejecting it. Being a man isn't a given; it is something proved, an ideal aspired to, and they just may find that in proving their masculinity and aspiring to that ideal they gain something more substantial than their sexuality to be proud of. In reclaiming and rediscovering masculinity, they may actually find themselves. I have.

And so have many other men that prefer men, who refuse to be defined by their sexuality alone. I've met and spoken with plenty of homos over the years who do consider themselves men *first*, who enjoy the company of men and relate to them as masculine peers, who enjoy male culture, conduct themselves in a manly way and find role models in great men. These *androphiles* are out there, living their lives independently, not really asking for much of anything from anyone. But because they are on the fringe they are still, to a great extent, men without a code. Many have their own personal codes, adapted from codes of masculinity learned from fathers and brothers and role models and applied to their own lives. That's basically what I'm suggesting here. However, I think it would be helpful to set some basic expectations—to establish some sense of shared values among these men. Not so that they can be better accepted by mainstream society, but to guide them—to help them be better men, for their own personal benefit.

There are some cross-cultural male-oriented values that have proved especially effective in getting the best out of men. These manly values hold men to a higher standard of behavior, make being a man something worth aspiring to and make manliness a quality that evokes a meaningful sense of personal pride. I firmly believe that you don't get the best out of males by coddling them or giving them a shoulder to cry on, but by challenging them. You get more from men by expecting more. And by expecting

more from themselves, men become more productive and less destructive. Their natural male drives are channelled in a more productive way. Codes of masculinity are regarded by gays and women as being oppressive—and they can be when taken to counterproductive extremes—but it is in striving to meet some sort of ideal, in trying to become the sort of man that other men admire, that men get the best out of life. With this in mind, I'm going to suggest a few values—manly values—that I believe would be especially productive goals for *androphiles*.

SELF-RELIANCE, INDEPENDENCE, AND PERSONAL RESPONSIBILITY

When someone says "be a man," they are usually encouraging a male to be self-reliant, to be independent or to own up to and take responsibility for his actions. There's almost a universal understanding that a grown man should be self-reliant—that he should be able to handle his own affairs and make his way through life independently without relying on others. There's nothing wrong with asking for help once in a while, so long as it's apparent that you've made your best effort before asking for assistance. Most men are happy to help men who have shown they can usually help themselves. Self-reliance is really what separates the men from the boys, and it's extremely important to most men; it's fundamental to their sense of self-worth.

When the gay community talks about self-worth and self-image, their therapy-induced take on it is far too reminiscent of personal affirmation—in the most whimpering, Stuart Smalley sense. It's the wound-licking of the scorned and defeated. It's self-encouragement for those trying to convince themselves simply to go on, to merely survive. There is a far greater sense of self-worth to be gained by knowing that you have stood on your own and triumphed over adversity without crying out for help or sympathy at every scratch from that oh-so-cruel or indifferent world. A popular gay anthem has always been "I Will Survive." If *androphiles* were in need of an anthem, I would suggest "My Way." It's a code of self-reliant, tenacious manhood written into song.

Self-reliance is an especially appropriate value for *androphiles*

because there's a good chance that many of them will live life without the support of an immediate family. There's a greater likelihood that many of them will live a substantial part of their lives single. It is essential that *androphiles* take pride in taking care of themselves and making their own way, because there's a greater chance that they'll *have* to live independently. They may form strong friendships, but men expect other men to pull their own weight—and they should. Friends who make themselves consistently burdensome quickly become distant acquaintances.

I've already ranted about the tendency among gays and gay activists to promote a culture of victimhood among homosexual men, about how they constantly blame society for their common problems. That's a poor strategy for gaining anyone's respect, let alone the respect of other men. Part of being a self-reliant man is taking responsibility for your own problems instead of blaming others. Everyone has a hard time or gets fucked over by life sooner or later. People may be sympathetic to your plight and see how things might be better for you if the world were different—but you'll never earn their respect unless you pull yourself together and rise above your situation. It might be comforting to believe that society had a role in your personal undoing, it may even be partially true, but blaming society is almost always an evasion of responsibility.

It's not society's fault when homosexual men get STDs or end up addicted to drugs. It's their own. And that will continue to happen as long as they run around having unprotected sex with strangers and taking no interest in their own preservation. Men need to take responsibility for the things that they do, but they won't unless we expect them to. It needs to become part of some personal code linked to their sense of self-worth. It's not a moral issue; it's an issue of self-respect. I have no moral qualms about men having no-strings-attached sex. Boys will be boys. Males perceive sex differently, and because sex between men doesn't result in children, there's really no reason to insist that they conform to the heterosexual ideal and form lifelong,

monogamous bonds.

If these boys are going to be considered men, they need to understand that their actions have consequences and they need to take responsibility for those actions. I think it would be healthy to start a dialog among these men and attempt to reach some sort of consensus on some loose guidelines for sexual behavior that encourage personal responsibility, personal preservation and self-respect.

When homosexuality was illegal, it was necessary for men to have anonymous sex in public toilets, bathhouses, alleys and the like. But the gay community still embraces anonymous, promiscuous sex and fosters a culture of nonjudgmentalism; gays only ask that homos have 'safe' sex. Any suggestion that backrooms, bathhouses and glory holes encourage destructive behavior is answered by cries of homophobia or prudishness.

Anonymous, promiscuous sex—no matter how 'safe' it is—increases personal risk. When men have anonymous sex at a high level of frequency, especially when alcohol or drugs are involved, the likelihood that they will not always use condoms or that they will put themselves in dangerous situations only increases. In many cases, the men I've known who frequented sex clubs or engaged in anonymous, promiscuous sex did so during downward spirals of self-destruction. They were trying to fill an emptiness inside by filling all of their *other* holes. It's perverse, but some of the most adamant defenders of venues for anonymous sex are HIV-positive. Many *still* have sex in such places, but the gay community refuses to pass judgment on such men or critique their behavior, and insists that these venues are actually *good* for the homosexual men because they disseminate information about 'safe' sex.

I appreciate the seedy, sexy aesthetic of the old homosexual underworld described by authors like Rechy and Genet. But sex between men is no longer illegal; it no longer has to take place anonymously in dark alleys and parks and backrooms. Encouraging this sort of behavior is destructive and regressive. The gay community, because it is a community that grew out

of an embrace of alternative sexuality, has an unhealthy, even obsessive relationship with sex. It encourages men to identify themselves not only by who they fuck, but by how they fuck, and we're treated to parades of people who take 'pride' in their sexual fetishes under the auspices of 'diversity.' The gay community makes sexuality a complete lifestyle, instead of merely a part of life.

Real sexual freedom doesn't require constant demonstration of that freedom. It is possible to embrace your own sexuality and feel free to have sex with whomever you like, however you like, without becoming a self-destructive hedonist whose life revolves around sex. The gay community advocates 'safe' sex. I'm advocating *smart* sex. Smart sex is not *heteronormative*. Being a male who prefers men does not mean you have to have anonymous, promiscuous sex. Homosexuals no longer have to sneak around, and it's time homosexual men got over demonstrating that. It's time they developed a healthier sexual ideal that puts sex in perspective and encourages responsible sexual decision-making. Straight men's sexual behavior is moderated by women. Because male homosexuality isn't moderated by women, homosexuals will have to take an interest in what Camille Paglia called "the custodianship of their own bodies."[30] They're going to have to take responsibility for their own health and well-being. They're going to have to moderate themselves.

The culture of anything-goes nonjudgmentalism isn't working. Homosexual men, as a group, need some sort of standard that promotes productive rather than destructive sexuality, and they have to stop being so afraid to differentiate between the two.

Androphiles should expect more of themselves and more of each other. Men who make responsible sexual choices and take responsibility for their own preservation *should* be held in higher esteem. That *should* be the ideal. Promoting that ideal will encourage more men to strive for it.

30 Paglia. *Vamps and Tramps.* "No Law In The Arena."

Achievement

Achievement is grossly undervalued in the gay community. The gay community is obsessed with appearance, and status is often 'achieved' via genetic roulette, or by what a gay wears, or how he does his hair, or what personal trainer he sees, or how often he visits a tanning salon. As an *androphile*, I can certainly appreciate a good-looking fella. And there's nothing wrong with wanting to look good. But appearances play a disproportionate role in how gays evaluate each other and how they expect to be evaluated. It skews their value system away from more substantive measures of men. Men aren't held in high regard by other men simply for how they look. Men judge each other based on their skills (what they can do) and on their achievements (what they have done). Placing value on concrete achievement drives men to achieve. Placing value only on how they look or how fashionable they are drives men to drink. As Bob Hoskins said in *The Long Good Friday*, "You know how bitchy queers get when their looks start to go."

Men who value accomplishment are more productive, and tend to become more accomplished with time. If a man's value rests entirely on his youthful good looks and his fashion sense, he's pretty much guaranteed a lifelong decline in self-worth. Focusing solely on youth and beauty gives men nowhere to go but downhill; it gives them nothing to grow into but the stereotypical 'bitter old queen.' Concerned members of the gay community often scold gays for being 'so focused on looks,' but I rarely hear them offer what homos *should* be focused on. I'll offer that they should be focused on doing something—anything—but wasting their time trying to look like 21-year-old fashion models. The bear community rejected the 21-year-old look, and although they still eventually managed to stratify each other by how much an individual resembled the *bear* archetype, bears were deemed attractive at virtually any age. That was a step in the right direction. And it is great to see men feeling attractive in their 50s. Since many homosexuals will end up being single at different times throughout their lives, it makes sense to promote

a standard of what is desirable that spans different stages of a man's life. But the focus still seems to be on being desired. I'd be a lot more impressed by bears if they stopped holding bear beauty pageants to see who can *look* the most "bear-ish," and instead became known for their remarkable prowess at chopping wood or building log cabins or something.

Being attractive is obviously something men who love men are going to want to be, and that's always going to be a factor in their overall self-esteem. But men need to focus on more than that if they're going to thrive and lead fulfilling, successful lives. Maybe it's enough for some really shallow dimwits to look back on their lives and say "I was really hot." But most people are not going to be perfect tens, and there's a lot more to do in life than be pretty. A lot of straight people can at least look back at the families they've raised, and derive a sense of satisfaction from the ongoing achievements of their children. Most homos will not end up raising families. And the synthetic opiate of 'gay pride' can't come close to the pride gained from actually doing something with your life beyond simply 'being gay.' By encouraging a culture of personal achievement, *androphiles* can derive a sustainable sense of satisfaction from all that they've accomplished in life. Creating the expectation that *androphiles*, like other men, are actually supposed to do more than look pretty will make them *better*, more productive men. And it will probably make them happier men in the long run.

One of the main reasons I wrote this manifesto, perhaps the primary reason, is that I see so much squandered potential in homosexual males. I see so many intelligent, talented, capable homosexual and bisexual males who are undisciplined, undermotivated and caught up in the superficial distractions that gay culture celebrates. *Androphiles* have an uncommon opportunity for personal achievement. While I strongly advocate a sense of personal responsibility among them, they're likely to have fewer responsibilities than straight men who have families. They're less tied down by financial and familial obligations, and they are freer to relocate and travel if they choose to do so. It is

easier for homosexual men to devote time, resources and energy to achieving their goals. Whether the goal requires attending distant conferences, conducting research, running a business, heading an organization, learning a new skill, relocating for a better job opportunity, campaigning, practicing, competing or writing a book—men without families simply have *more time* to follow their passion, whatever it might be. While other men struggle to keep food on the table or get new sneakers for Junior, *androphiles* can use their extra income to fund their endeavors. This is a significant advantage. *Androphiles* could become *leaders* of men in virtually any field with comparative ease. By holding personal achievement in high esteem, *androphiles* could become more than men; they could become *great* men.

Integrity

It's easy to get away with a lot these days. Most of us don't settle in small communities where we live and die by our reputations. It's easy to weasel your way out of things, and a lot of people won't hold you accountable for telling a bit of a fib, or breaking a promise or shirking your responsibilities—so long as they don't lose any money in the process. But there's something pretty damn refreshing in my book when I truly meet a 'man of his word,' someone who does what he says he's going to do, and doesn't say things he doesn't mean. And when he can't follow through, he has a good reason—something beyond 'I totally didn't feel like it'—and he apologizes sincerely. That's the kind of man I want to be around and have among my friends. I'll be the first to tell you that lying gets a lot of people ahead in life, and that breaking promises is sometimes easier than keeping them. But I just don't operate that way; I don't think it's conduct becoming a grown man. A man is someone you can count on, who is what he says he is.

People don't expect a lot from gay men. They expect gays to be fruity and flaky and emotional and inconsistent. In my experience, this does often tend to be the case. And I think it reflects poorly on the gays who act that way. It's more unmanly

than wearing a dress. If *androphiles* are really going to reclaim a sense of manhood, they need to value integrity in themselves and others. They need to be accountable and forthright—maintaining personal integrity and taking responsibility for your actions are deeply intertwined. If you're going to call yourself a man, you need to be a 'man of your word.'

Respect

Profound respect is earned through achievement, self-reliance, personal responsibility, and integrity, among other things. I've also already touched briefly on self-respect, which is related (or should be) to these values, especially in males. If you have a sense of self-worth based on these things, you're less likely to treat yourself poorly or put your body in unnecessary peril because you'll want to remain self-reliant and independent and continue to achieve the goals most important to you.

What I want to discuss here is a baseline respect between men. If *androphiles* are truly to rejoin the brotherhood of men, it is absolutely essential that they treat other men with the same modicum of respect that they'd want for themselves. This is not, it must be said, a free pass for assholes. But if *androphiles* want to be respected by other men, they must be prepared to offer the same respect in return—especially when it comes to another man's sexuality.

I was talking with a young, reasonably attractive straight guy recently, and he admitted that I was the first homo he felt comfortable around, because he didn't get the feeling that I was waiting to hit on him and I wasn't bombarding him with nonstop sexual innuendoes. Another straight fellow told me a story about a homo he knew who always seemed to have a beef with straight men, who was openly antagonistic and projected a barely disguised air of superiority to them. Neither story surprised me, because I've watched homos interact with straight men over the years and seen, on many occasions, both open disdain for straight men and overt sexual harassment in situations where the straight men did absolutely nothing to

provoke these behaviors.

Throughout this manifesto, I've advocated that homosexual men see their sexuality as a difference in sexual preference that shouldn't exclude or separate them from the ranks of men. However, this won't mean anything unless homos learn to respect the sexual preferences of other men, as well. Homos are friends with other homos who are 'not available' all the time. It could be because they're in a relationship, or simply aren't attracted to one another, or have decided that they don't want to get together sexually for whatever reason. They respect those boundaries with ease. And yet, so frequently, I see them cross the same boundaries with straight men who are relative strangers. It's one thing to tease a good friend and expect the same in return, knowing it's harmless fun. It's quite another to leer at, taunt and provoke men about their sexuality and then expect them to respect your 'special' preferences. The homos who really get along well with straight men are those who respect other men's boundaries and preferences, instead of just demanding respect for their own.

One of the perks of being an *androphile* is having access to the private world of men. We have access to showers, saunas, locker rooms, bathrooms and the like. We are flies on the wall, seeing men in ways that straight men would love to see women. If *androphiles* are to be treated like regular guys, discretion in these situations is essential. Private male zones have to be respected. They have to remain private male zones—not become our strip joints, with homos snapping camera-phone pictures, making comments and leering creepily at other men. By not respecting the boundaries and preferences of other men, *androphiles* only widen the unnecessary divide between homo and hetero. If homos don't want to be regarded as creepy perverts, they need to stop behaving like creepy perverts.

Respecting another man's boundaries means respecting his manhood, and if *androphiles* want to be respected as men, they need to respect the manhood of other men as well. They need to respect not only straight men, but each other. Men like

to have their manhood affirmed, precisely because they value it. That's why they frequently refer to each other as 'man' as a friendly term of endearment. Treating another man like a man will generally inspire him to treat you the same way.

There are some things that are meant to be 'just between men.' As a man, you know how you'd like to be spoken of, and you know what information you feel comfortable with others sharing about you. Things men do or discuss in private are to remain between them, unless otherwise noted.

We live in an increasingly gossip-driven culture. Women have always been known for talking to each other about things that were meant to be private. Some of the boyfriends of girls I've known would probably break up with them if they knew the things these girls have told me (and frequently, anyone within earshot). Some women are notable exceptions, but most women are talkers, and they often talk about things they probably shouldn't. Even men these days are more prone to gossip; popular sports-news programs are ridiculously gossipy, and the personal lives of public figures have long been fair game for water-cooler conversation. It's part of human nature. I've certainly been known to do it myself. But many homos seem to have no boundaries at all. Many of the most well known figures in the gay community are gossip mavens. Bitchy gossip is a cornerstone of gay culture. Sometimes, gossip is harmless and in good fun. Often, however, it's mean-spirited, or merely revealing private information for the sake of having something interesting to say.

It would be refreshing to see *androphiles* learn how to keep things 'between men.' If a man reveals something intensely private to another man, or has sex with him, the details of the exchange should remain private. They shouldn't become fodder for conversation the next day with anyone who will listen, and they shouldn't be broadcast in a bitchy manner if the two men have a disagreement or go their separate ways. That's fucking tacky, and unmanly to boot. Oh, I know it's tempting, but that's a low, passive-aggressive form of revenge if there ever

was one. And when that's the norm, you can only expect the same disrespect in return. Wouldn't it be better for all parties concerned if it was understood that private exchanges would remain in confidence? I believe that *androphiles* can and should differentiate themselves from rank-and-file fags by treating each other honorably and respectfully.

Masculine Honor

There have been many different codes of masculine honor through the ages. Some are occupationally specific—different things are expected of a warrior than of a civilian. But the reason these codes tend to be so powerful is because they are easily attached to men's fundamental male identities; these codes of honor become part of what it means to be a man. They play on the natural male desire to find meaning in manhood. Honor codes are most successful when they resonate with *essential* qualities of masculinity and give direction to natural male tendencies. They give men something to strive for, to live up to, that is in harmony with the condition of maleness. Men will often go to great lengths to prove they deserve the title of 'man,' as defined by these codes. Sometimes this can be quite productive, as with gentlemanly behavior, courage, etc. Sometimes it can be catastrophically destructive. It depends almost entirely on the code and how it is interpreted.

I'm not suggesting that *androphiles* be willing to commit ritual *seppuku* to protect some sort of romantic, samurai honor. Yukio Mishima's autobiographical *Sun and Steel* is a perfect example of an *androphile* rediscovering masculinity and a culturally specific masculine code of honor, but I wouldn't want *androphiles* to replicate his magnificent suicide.

Right now, however, men who love men have no prevailing code, no sense of expectations to live up to at all. Men with no productive code tend to run amok; their natural male energies are given no direction, and tend to find outlet in unproductive ways that are bad for the individual and bad for society. Male homosexuals have remained largely without a code, though I've

read of some codes within early gay biker and leather groups, in part because they found themselves on the outside of so many other mainstream masculine codes.

The gay movement has been in part based on the feminist idea of 'liberation' from codes, but these 'liberated' men are often perfect examples of men behaving badly. Without a sense of masculine honor, of what it means to be a man, males merely do whatever they want. The nonstop 1970s orgy of drugs and sex in the male homosexual community is what happens when 'liberated men'—men without a code—run wild. It quickly became counterproductive, both for individuals and for their community, and spread disease like wildfire. What tempered that behavior was not a growing sense that it was unproductive, but *fear* of disease and death. Today, that fear is less powerful, and the same tendencies are emerging again—as evidenced by the increasing popularity of 'barebacking.' Rampant drug use has never really gone away. 'Liberation' from codes is a nice idea, and there are fiercely independent and productive individuals who develop their own personal codes of behavior that serve them well. But I think its clear that these men as a group would actually benefit from some sort of expectations being placed on them; they'd benefit from having some sort of productive ideal to live up to.

What I've suggested here is a loose code of masculine honor, based on values like self-reliance, independence, personal responsibility, integrity, self-respect and respect for other men, that have resonated with males throughout the ages. These values have been common themes in many codes of masculinity, and they've inspired countless males to be better men. They're productive values for both individuals and the group.

Being a man has to *mean* something, or it's nothing more than 'gender expression.' And being a man *does* mean something to most men. Beyond the superficial macho posturing that gays and feminists seem to focus on, there's something more profound that governs the behavior of men—a sense of identity that is *earned* through adherence to a set of masculine values.

It is by striving to live up to a high standard of manhood, by living according to a masculine code, by earning—not simply taking—the title of 'man,' that men gain a sense of honor, a sense of masculine pride that is far from fleeting. Being a man is not something you prove once; it's something men strive to embody throughout their lives. There is honor in being a man, a sense of pride in that consistently earned identity that many men experience from adolescence through old age. It's why little old men still open the door for little old ladies; being a man *means something* to them. They have a sense of masculine honor that doesn't fade with time. It's a code that works in concert with their innate maleness and guides their behavior in many productive ways.

This manifesto isn't just about reclaiming masculinity in theory; it's about reclaiming it in practice. It's about taking a second look at *what it means to be a man* and applying that in a practical way, for their own benefit, to the lives of men who love men. It's not a scold for homosexual males, it's a call for *androphiles* to take back a sense of masculinity and adopt a code of masculine honor, a masculine ideal, a sense of discipline that will help them to thrive as individuals. It's not just about encouraging them to think of themselves as men, it's about making them *better* men.

CHARACTER, NOT CARICATURE

It will inevitably be said that I just want homos to 'butch up.' In a sense, you've got me pegged. Yeah, that would be a nice change of pace. But that means something different to me than it means to a lot of gays. There are already subcultures of homos who have 'butched up.' They've grown beards and built muscle and worn uniforms and bought motorcycles. All of that is certainly more aesthetically pleasing to an *androphile*, but it frankly means dick if there's nothing underneath, no true masculine character there to back it up. Being a man isn't about lining up in faggy beauty pageants to see who *looks* the most masculine. I almost lost my lunch reading *Bears on Bears*, which, except for a few patches, read like a bible for furry feminists. The leather scene is no better. Though I've always found that dark, deviant biker look appealing, for all of the malevolent posturing, a lot of these guys out quickly as peace and love powder puffs competing in a pissed-off pose-down. This is typical of gay culture; gays seem to embrace masculinity only as a pose, as a vulgar caricature of men, comparable to the drag queen's vulgar caricature of women.

Gender polarity is given to extremes. Masculinity is contrasted with femininity or, in men, effeminacy. So, as when we think of examples of femininity we may picture a curvy, delicate, big-bosomed woman with long hair and a somewhat submissive, sweet demeanor; it is to be expected that when many people think of masculinity they picture the extreme opposite. We naturally reach for a caricature—a man who is hulking, freakishly muscular and almost insanely aggressive.

Professional wrestlers are perfect examples of extreme masculinity. Their male bodies are blown up to comic-book proportions and displayed proudly, to awe and intimidate. Their bulging pecs are armor; their arms are not arms—they're *guns*. They are superheroes of masculine aggression—berserkers issuing macho challenges in barks and growls with vein-popping, teeth-gnashing intensity. When the cameras switch on, they

are volatile men about to explode. And when they do explode, their combat is no 'sweet science,' no combination of effective holds, targeted punches or tactical takedowns. Their battles are bigger than life. Their moves are massive. Instead of wrestling a man to the ground and locking him into submission, they break a folding chair over his back or throw him headlong into the audience. Their kicks are flying kicks, their takedowns are smackdowns and body slams. Their opponents are not defeated; they are vanquished. Instead of shaking hands, they stomp on their opponents' chests and stand as smug as silverback gorillas.

Professional wrestlers are the thespians of testosterone; their masculinity is theatrical. If all men were really like this—if *these* men were really like the characters they play—they'd either be heavily medicated or in prison. But men get a kick out of these hypermasculine monsters; they enjoy them. I enjoy them. Professional wrestlers, action-movie characters, television cops, gladiators, sports heroes and the men of myth and legend are concentrated distillations of the raw, *essential masculinity* that's a part of every man. If most of us are beer guys, they are Everclear. Hypermasculine men tap into a primal, aggressive, distinctly male part of every man. And men love them for it. As a man who loves men, I think these men are fucking magnificent.

But being a man is not the same as becoming these men. If it were, the whole world would be one big nonstop roadhouse brawl of feral masculinity. While guys ape these men for fun, or mainline that hypermasculine fantasy every once in a while as a source of inspiration, they usually don't want to become these androgen animals in every way. Macho idols are masculine role models, but they're not the only masculine role models. They're not real men so much as surreal men. They usually lack depth, subtlety, finesse—they are made-up characters that lack real character. Men are a much more diverse lot, and there are many modes and models of masculinity. There's a richness to masculinity that is lost when it is defined only in terms of its most extreme examples.

Gays tend to reach for those extremes even more than

most. When they speak of masculinity and men, especially in effeminate circles, they speak as if masculinity is embodied solely by construction workers, rednecks, dimwitted jockish frat boys, and macho thugs—the same hypermasculine types who are most likely to ostracize effeminates. Gays are happy to talk trash about hypermasculine men and portray them as hopeless dimwits; it's a passive-aggressive reflex that's one of the defining characteristics of gay culture. Because they were powerless against the jocks and rednecks that once kicked them to the curb, gays have frequently retreated to an obsession with what David Harris called the "aestheticism of maladjustment" and imagined themselves, no matter how low their birth, to be part of a "secret society of upper-class aesthetes."[31] The idea that straight men are culturally or intellectually inept is fundamental to the tortured queen's delusion of adequacy. The gay sensibility won't allow for the reality that straight men have been directly responsible for the bulk of the cultural achievements of the human race. It doesn't matter that straight men are often valedictorians, certifiable geniuses, insightful historians, writers, composers, and critically acclaimed artists. A masculine straight man who is at once a warrior, scholar and connoisseur is inconceivable to many gays. If they'd snap out of their gay dream, gays might realize how fascinatingly cultured, knowledgeable, skilled and intelligent many rather masculine straight men have become whilst homos were busy finding the best salons and the hippest new restaurants. It would probably be painful for them to admit that the renowned chefs of those hip restaurants are virtually all fast-car-driving, sports-loving womanizers who *also* happen to know more about exotic food and fine wine than your average fag.

But perhaps gay men like their straight men 'big and stupid' for other reasons as well. There has always been a tendency among homosexual males to eroticize, fetishize, and virtually deify their heterosexual male oppressors. In adolescence, as sexuality is finding its focus and images are burned into the erotic imaginations of youths, many bullied homos develop

[31] Harris, Daniel. *The Rise and Fall of Gay Culture.* "The Death of Camp."

a bully fetish, a love-hate fixation on the angry young bucks who push them around. All straight men become caricatured bullies, exotic monsters of primitive masculinity. This sexual fixation on the straight man as beautiful bully and brute has found literary expression in Genet, and has been filmed by underground filmmaker Kenneth Anger. *Fireworks* (1947) is a dream sequence wherein a young Anger approaches an impressively built sailor who is obsessed with his own body and thuggish masculinity. When Anger offers the sailor a cigarette, the sailor smacks him around and Anger falls to the ground in apparent ecstasy. What occurs next is essentially a fag bashing that turns into a conflict between the sailors, who break into a brawl, which Anger seems to love even more. The original sailor then appears to save Anger; he transforms from bully to eroticized hero. This theme is repeated in the more famous *Scorpio Rising* (1963), which deifies the biker/delinquent as violent rebel god and includes another homoerotic beat-down— with the biker character, Scorpio, looking on as he's compared to Adolf Hitler, Christ, the Devil, and Death. Another more familiar example can be found in *Gods and Monsters* (1998), as an aged James Whale superimposes Frankenstein's monster and his own macabre World War II memories on a strapping young ex-Marine, creating a potent erotic chimera.

The exaggerated, eroticized masculinity of the potential bully seems to be reflected in the three masculine archetypes most often celebrated by the gay community: the leatherman, the bear and the jock. Both Anger and Tom of Finland contributed to the gay fetishization of the rebel biker as leatherman. Bears can be easily traced to the redneck trucker or construction/factory worker type, who can be seen as both a furry blue-collar hero and a potential threat. The frat boy/jock type is so pervasive in gay culture that the archetype practically defines the mainstream gay erotic aesthetic. The smooth, young jocks of Abercrombie & Fitch advertisements are potentially both beautiful bullies and stone-cold, untouchable gods. Gays may max their credit cards in high-end boutiques and dress

to impress each other in fashionable scenarios, but when they really want to get laid, you'll most often find them in casual, jockish clothes. Jocks and their gay imitators have been pulling from the same racks for years; they're imitating each other, and it is becoming increasingly difficult to tell them apart.

Until the gays open their mouths, that is.

Many of these posers still "walk like Tarzan and talk like Jane."[32] Their masculinity is a hypermasculine pose that's self-conscious and one-dimensional. They become cartoons of men. Their concept of what it means to be a man is based on hypermasculine extremes, not *essential masculinity*. Gay masculinity is a fetishistic, masturbatory reading of masculinity; it's mute, like a page torn from a porn or bodybuilding magazine. Gays stop at sartorial and physical imitation, or cop a particular hypermasculine attitude drawn from some dreamy archive of fuzzy pornographic memories. 'Masculinity' in the gay community is more often than not a form of drag; it seems shallow and affected and silly—like some Halloween costume designed by the Village People. Many gay men want to *look* like men, but they're unwilling to try or uninterested in really *becoming* men. They never flesh out their characters. There's nothing wrong with enjoying a certain hypermasculine archetype, but real masculinity runs deeper than that. This is not true of all men who belong to gay masculine fetish subcultures. Some really do have a more nuanced, *androphilic* appreciation for masculinity. Many younger homos today lack an extreme bully fetish because they were never really bullied or violently ostracized; many are comfortable enough around their straight friends to understand the difference between real men and those that inhabit the pornographic fantasies of the excluded.

I appreciate men too much to reduce them all to cartoonish, chest-thumping apes. Chest-thumping apes are impressive, even hot, but there's more to most men and there's more to being a man than that. Real masculinity is so much more diverse; there are so many other ways to express masculinity that aren't

[32] Quoted from the Greg Araki film "Mysterious Skin."

captured in a handful of popular gay masturbatory fantasies. At its most basic level, manliness is a quality of character that is unmistakably, tangibly male. It's a confident synthesis of *physical*, *essential* and *cultural* aspects of masculinity.

Men can be distinctly, wholly masculine in character without being hypermasculine. Real-life examples are everywhere. Film, however, provides a common frame of reference.

Robert De Niro is a masculine icon admired by a wide range of men. As Michael Vronsky in *The Deer Hunter* (1978), he is absolutely masculine in behavior, appearance and demeanor—but that masculinity isn't exaggerated or extreme. Vronsky is a blue-collar guy who lives in a small town, but he's no dopey redneck stereotype. He's quiet, but not shy; he's reserved, but warm and likable. Vronsky is *homosocial*; he prefers palling around with his guy friends to chasing skirts, though he does have an eye for Meryl Streep's character. She's someone else's girl, so he respects that and keeps his distance. He and a few friends have enlisted in the army, and after a wedding and a bit too much to drink, anxiety about going off to Vietnam prompts a late-night streak through the neighborhood. De Niro's body is completely masculine, but he doesn't look like a pumped-up action hero or a modern gym-toned actor. He just looks like a regular guy who does physical work for a living.

The next morning, he and his hung-over buddies head for the mountains for one last hunting trip together. Vronsky takes pride in hunting; he values precision and the tradition of hunting. He has a low opinion of those who behave disrespectfully and think hunting is about wandering through the woods drunk with rifles trying to kill anything they stumble across. The things he does, he does with dignity and honor, and this defines him as a man. The film then shifts to Vietnam, where he and his friends are prisoners of war, and they are forced to play Russian roulette with one another for the enemy's entertainment. Vronsky takes charge of the situation, not because he's a blowhard, but because *someone has to*. He manages, with considerable though never ostentatious courage, to handle the situation and get his

comrades to safety. The rest of the film deals with the aftermath of the Vietnam experience, and as I highly recommend it, I won't spoil it for those who haven't seen it.

There's nothing about Vronsky that is in any way effeminate or womanly. He is completely masculine, but not hypermasculine. He's manly, but he's no posturing he-man. He's not a brilliant man, but he's a man of depth, dignity and some emotional complexity. When I think of hypermasculinity, of masculine caricature, I think of professional wrestlers and those who behave in a similar fashion. But when I think of masculinity, I think of men like Vronsky. His masculinity is uncompromised, but it's real—he's a *real* man.

Vronsky may be a heterosexual character, but it's also easy to picture him as an *androphile*. He is somewhat ambivalent toward women. His most heroic and honorable actions are inspired by love for his close male friends. His world is *androcentric*; male camaraderie and masculine interests are most meaningful to him. He's the sort of man many *androphiles* could adopt as a masculine role model, regardless of body type or other interests.

Real masculinity often isn't all that showy. It's not just an attitude or a pose; it's about character—real, palpable, unaffected masculine character that comes from who a man is, not just how he looks or talks. If some same-sex-oriented males want to be perceived as being truly masculine, they need to find that natural masculine character within themselves and develop it. They need to bring who they are into harmony with how they look. *Androphiles* need to put the superficial signifiers of hypermasculinity in perspective. Most guys have fun with hypermasculine imagery and macho behaviors, but it's often tongue-in-cheek; these things don't truly define them as men. Most men are palpably masculine, but that masculinity is far more natural and less affected. They are *real* men. Their manhood is part of them, not just a costume. If *androphiles* want to be and be perceived as *real* men, they'll have to evolve beyond facile hypermasculine caricature and grow into men of true masculine character.

Masculine character is rooted in the firm sense that one is a man and belongs among men.

True rites of passage are rare in the modern world. Jews have bar mitzvahs; fraternities and some occupations offer rudimentary rites of passage that bond men together—sometimes despite major differences in background, social role and personality. Rites of passage accelerate the initiation into manhood. After passing through a harrowing ordeal with stoic masculine dignity, or accomplishing some difficult task, like taking down a full-grown antelope, young males are either welcomed into the world of men and 'shown the ropes' or they're shunned completely.

But modern initiations into manhood are generally less cut-and-dry; initiation gives way to progressive socialization. The modern path to manhood isn't short and linear, but long and labyrinthine. There are stops and fresh starts and there are nearly limitless routes to developing a solid sense of masculinity, a real masculine character. Men initiate one another into the religion of 'man'; they introduce each other piecemeal to the world of men through association, competition, affirmation, rejection, and the exchange of information. Gays tend to portray straight men as a one-dimensional bunch, but groups of men in modern society are actually extremely diverse. Each male finds out where he's comfortable based on what ideals of masculinity and behaviors appeal to him, and what interests he has in common with various men and various male groups. He determines his assets and sees how various men and groups of men evaluate him. Men challenge and test each other. Each man determines what kind of man he is, and what kind of man he wants to be, based on information gained during this progressive enculturation. He finds the most personally satisfying outlets through which he can express his essential masculinity and develops a masculine identity, a true masculine character that is a unique synthesis of *physical*, *essential* and *cultural* aspects of masculinity.

Homosexual males throughout history generally remained closeted or bisexual, and as a result were still socialized by other

men. They knew the male world, even if they were also part of a clandestine homosexual underworld. Because of the stigma of effeminacy, men who experienced same-sex attractions may have privately questioned their own masculinity, but unless they were aristocrats, they likely still had to pull their weight in the world of men. However, with the rise of the Gay Rights Movement in the twentieth century, homosexuality as a lifestyle became truly viable; same-sex-inclined males were encouraged to allow their underworld to become their whole world. Upon 'coming out,' homos flocked to gay ghettos and associated almost exclusively with gays and fag hags. Rarely had homosexual men been so isolated unless they were imprisoned. In the gay world, they became *clones*—actually a popular term for mainstream gays in the '70s. And while the gay world is finally starting to fragment due to widespread assimilation, there's still an incredibly homogeneous gay culture that can be quickly observed by visiting established gay bars in any corner of the United States, and possibly the Western world.

In a sense, the gay male world is just another male social group. But instead of being merely different from other groups, it is in many ways opposed to all of the other male groups. Most male groups offer *cultural* variations on masculinity; they are sects within the male religion—at times as different from one another as Mennonites and Mormons—but all with some shared reverence for *essential masculinity* and the idea of manhood. Homosexual men, however, have always been cast as heretics, and excommunicated from the religion of men. Gay culture appropriated the stigma of effeminacy, and gays became bitter atheists—proud infidels whose appreciation for manhood was as distant and disconnected as any atheist curator putting together an exhibit of foreign religious artifacts. Effeminacy and masculinity are as opposed as Heaven and Hell, north and south; they're mutually exclusive behavioral polarities with a strangely symbiotic relationship. Masculinity and effeminacy are two paths that lead away from each other, but they are also in some sense defined by each other.

If a man chooses the masculine path, his innate maleness is nurtured; he develops a masculine character. By choosing the gay path, he never fully develops into a man. He often remains an androgynous Peter Pan, even despite a quasi-masculine appearance. Harvey C. Mansfield hit the nail on the head when he recently wrote, "Manliness is an exclusion of women but a reproach to men, to unmanly men."[33] In response, I believe gay culture is a reproach to manly men. Gay culture critiques, stifles, and qualifies masculinity. It encourages effeminate affectations and effeminate interests. Most straight men are admittedly not engaged in some elaborate quest for manhood; they are socialized into the world of men and develop their masculine character through casual interactions. I believe the same thing happens within the gay community.

Progressively, as a homosexual male associates with more and more gay men, he will naturally be exposed to more gay interests and more aspects of gay culture. He will develop more gay behaviors in much the same way that teenagers associate themselves with a social group and pick up that group's distinct slang. The more *gay* a male becomes—as the gay world becomes a more important part of his life—the more disconnected he will become from straight men. The world of men will become increasingly alien. If all of this happens while he is still quite young, as it often does for many gay males who explode into gay life upon coming out, he may *never* establish a sense of belonging among other men. I've looked on as many gay men actually scolded homos for preferring the company of straight men. Gays assure each other that they will never be accepted by other men in the long run, that straights will inevitably 'turn on them.' *We're your _real_ family.* Like some gay-identity Gestapo, gay men with a deep emotional investment in the gay community often vilify masculine-identified homos as *straight-acting*, implying that they are self-hating fakers and turncoats. Because gay

33 Mansfield. *Manliness*. Mansfield separates manliness from masculinity, but I view the terms as being virtually interchangeable. I use them that way here, as I believe they are used in everyday conversation.

culture is a response to masculinity, even a revenge against it, the gay community eventually manages to mold homos in its own image—even if they don't really start out that way.

This is changing slightly today. Young straight men are more accepting of young homos, and homos are less insulated by gay culture. Their range of experience is broader and they move about freely in a variety of straight and gay social groups.

However, the stigma of effeminacy is still firmly in place. Masculine ideals are still, for the most part, reserved for straight men and shunned by gays. Masculine pursuits are still considered the domain of straight men, and there's really very little culture among homos that will, in the absence of straight friends, sustain endurting masculine interests. Sooner or later, most straight couples will end up having kids. Their interests, along with the direction of their lives, will change and they will have less free time. There's a good chance that most homos will eventually be left with each other.

There's really no established masculine path for homosexual men. Everything about the gay community leads in the other direction. There are a few masculine subcultures, but as I've mentioned, they are primarily fetish cultures and rarely encourage *active* masculinity. They don't require a man to *do* anything; they merely require him to *look* a certain way. The masculine subcultures within the gay community don't develop masculine character, they encourage aesthetically pleasing masculine caricature. For all of their visual pomp, many members of these so-called-masculine gay subcultures identify legitimately masculine behavior as *heteronormative* behavior. But masculine behavior is not *heteronormative* behavior; it's distinctly male behavior.

Androphilia is an attempt to inspire a new male-oriented subculture, a movement away from gay culture that will develop what I believe to be the natural male potential of homosexual men—the potential in these men that gay culture ignores or actively suppresses. The stigma of effeminacy is ancient, but the time is right to challenge it. Cultural expectations for men are

in flux, and have been since women challenged men in the work force. Men aren't sure what the rules are anymore. However, a resurgent masculinism is on the horizon. As long as men share power with women, they will have to make major compromises—compromises that *androphiles* may not always be forced to make. But men won't allow women to reproach them and dictate their masculinity forever. If *androphiles* want to be included among the ranks of men in the future, they have to stake their claim now—while gender roles are still being radically reconsidered.

This will require a movement, but not a political one. The meaningless marches, candlelight vigils, and whiny media manipulation frequently employed by gay advocates only reinforce the stigma of effeminacy. These passive-aggressive activities will only demonstrate on the public stage that homosexual men really *are* mama's boys who can't handle their own affairs, and who will never be able to pull their shit together until everyone *else* accepts and affirms their lifestyle. Challenging the stigma of effeminacy will require a movement whose action takes place first on the personal level. *Androphiles* will have to disprove the stigma of effeminacy not by asking others to perceive them differently, but by living differently. Masculinity is not just a pose, it's a lifestyle. Now is the time for *androphiles* to start living that lifestyle. Now is the time for *androphiles* to force people to reconsider their perceptions of homosexual males, not via petition, but by defying their expectations. If there are homosexual males out there who want to defy those expectations, who are tired of being perceived as deficient men based only on their sexual preference, who are tired of allowing liberal feminist gays dictate their opinions and agendas, who are tired of everything the gay lifestyle has to offer—now is the time to take control of the situation.

As a penalty for homosexual acts, the men who've engaged in them have been historically castrated, both physically and psychologically. They have been banished from the world of men, cast out and encouraged to perceive themselves as deficient, inferior, and fundamentally unmanly males.

For centuries in the West, homosexual males have been stripped of their manhood, their masculine heritage, their place in the world of men.

I say it's time we took it all back.

TAKING BACK MASCULINITY

What do you know—really *know* about homosexuality, about masculinity, and about yourself?

Have you perhaps been complacent and allowed others to limit and define you, even as you 'came out' and declared your 'freedom?'

In accepting 'who you really are,' have you actually been stifling a part of yourself—stifling something real, something primal, something unmistakably male?

Is it possible that you've accepted enshrined smears and insults as unquestionable truth, taken to heart the widespread belief that we, as men who prefer men, are flawed men, half-men, not-quite-men, *something else*?

Are we not men?

Many of you who are reading this have already rejected the idea that homosexual desire is indicative of a defective masculinity. You've carved out a niche for yourself in the world of men and gained the respect of other men. When other men discover your sexual preference, their perceptions about who a homosexual man can be are forever altered and expanded. I've known many like you.

However, many others still have one foot planted in the gay world. Try pulling it out and walking around a bit. See how the other half lives, so to speak.

Call it a dare.

Many homosexual men slip into the gay lifestyle and never look back. They slip into a comfort zone and never really challenge themselves. Being a gay teen might be rough, but being a gay man is easy, especially if you're reasonably good-looking. It's an instant lifestyle. Instant sex. Instant friends. Instant culture. Just add vodka.

Most males grow up sharing some common ground—some common experiences and common interests. 'Coming out' is a fork in the road; gay males start down the gay path and move further and further away from that common ground. Their

identity becomes conflated with the gay identity. They surround themselves with gays and women who influence their interests and the way they perceive themselves over time.

People make the mistake of stifling their personal evolution by setting limits on themselves, based on what they liked or disliked as children. Who you were as a child or even an adolescent is not necessarily who you *really* are or who you could conceivably be. If you had a bad experience with something, or were pushed into something you didn't want to do when you were younger, isn't it possible that it simply wasn't right for you *at the time*? I've found that I genuinely enjoy many things as a grown man that I despised as a child, or dismissed as a teen.

I'm not asking homos to repress themselves. My theory, based in part on my own experiences, is that many of these men have been doing just that for years. I believe that they can be more than what the gay community has encouraged them to become. I think that they're missing out on a whole realm of potentially fulfilling experiences that they have been told are not for people like them. I think they're foolishly rejecting masculine ideals that have always inspired men to lead more vital, productive, satisfying lives.

A few years ago, I started exploring the world of men. Instead of merely worshipping the masculine in other men, I awakened my own latent masculinity. For me, *androphilia* has become more than a sexual attraction to masculine men; it expanded to become a passion for the world of men, the pursuits of men, for being a man, and for living a masculine life.

This manifesto is a challenge. It's not a plea for fags to start 'acting like men.' It's not a casting call; I'm not interested in 'acting.' It's a call for homos to truly become men, to really awaken and develop their own innate masculine characters. It's a call for men who love men to leave the gay life behind, to trace their steps back to that common ground of boyhood experience and clear a path in the direction opposite to *gay*, without apologizing for their sexual preference. Only when that path is well worn, when many *androphiles* have proven by example

that they are not constitutionally effeminate—that they are not 'hermaphrodites of the soul'—will the liberation of males with homosexual and bisexual preferences truly be complete.

Many misguided gays and feminists want to free people from constructs of gender by ignoring natural differences between the sexes and retraining men to be more like women; they want to liberate women and effeminates by destroying masculinity.

I don't want to destroy masculinity. I want to stake a claim to it for myself and other *androphiles*. I believe manliness is of value to males as individuals and in groups. Masculinity should be championed and honored, not subverted.

If reclaiming masculinity is a challenge you choose to accept, I've offered below a few suggestions for how you might go about beginning that process or consciously expanding it. It's not a complete process; it's not a twelve-step program. Men may be 'as alike as eggs' in some broad sense, but they lead remarkably different lives. This manifesto isn't a training guide for aspiring lumberjacks. Men come in all shapes and sizes. They have different talents and interests and aesthetics. Each *androphile* will start from a different place and make his way to a different end. These suggestions are just a few basic principles and catalysts for self-exploration that I've personally found to be effective, inspiring, and transformative.

Use Language as a Tool to Alter Perception

Language is important. Words mean something; they're more than just combinations of letters. The word *gay* carries many effeminate connotations. It also binds you to people who will be openly hostile to the very idea of reclaiming masculinity, as well as a lot of extraneous concepts that have nothing to do with homosexuality at all. Lighten your load, and avoid the word *gay* whenever possible. Switch to *andro* mentally, and use it in situations where others will understand what you mean.

Androphilia is just a word, but it sets up a different paradigm for understanding your own sexuality. It severs sexual desire from sexual identity and describes only desire. Instead of identifying

you as a different sort of man and a member of a minority ethnic group, it allows you to perceive yourself as a man, essentially like any other, who simply has a different sexual preference based on his desires. The precise origin of homosexual desire is fodder for debate, and definitive answers don't seem to be immediately forthcoming. All that matters in everyday reality is your personal experience of that desire, and whether or not you choose to act on it.

ABANDON AFFECTED GAY BEHAVIORS

Stereotypically gay behavior is amplified effeminacy; if you do not believe that homosexuality and effeminacy are the same thing, there's nothing *self-loathing* about stripping away layers of gay affectation. Gay behavior is learned; it is part of the gay socialization process. Young homos affect gay behavior to establish a sense of belonging in the gay social group, but these affectations also exclude them from other social groups. To most people, including myself, extreme gay affectation signals a desperate need for any kind of attention—even negative attention. I am referring specifically to overtly theatrical gestures, lisping and typical 'princess' behavior. But many other minor gay behavioral ticks are viral; people pick them up simply from hanging out with homos and fag hags.

Honestly evaluate your own gestures, speech and behavior. There's no need to pick up some new affected macho style of speech or to adopt some ridiculous macho posture. It is enough to strip away the layers of learned gay behavior—to relax, to speak plainly in your own natural male voice.

ALTER YOUR EVERYDAY INFLUENCES AND EXPLORE MALE CULTURE

They say that the color of a room can change a person's general mood. In November, shopping malls start playing Christmas music to get people into feeling the Christmas spirit—and spending more money. When you leave a particularly engrossing movie, don't you carry a bit of it around with you for the rest of the day? It is difficult to overestimate the compounded

psychological influence of your everyday environment and the things you choose to expose yourself to on a regular basis.

Many gay men's music collections consist primarily of female vocalists, and I believe that over time this has a profound effect on their psychology. *They literally have women's voices in their heads.* Balance out your collection by acquiring some male-oriented music; awaken yourself to the voices of other men.

Explore male culture. Seek out new and classic films that men typically enjoy. Find some male-oriented subject matter that interests you and read up on it, or, if you prefer fiction, pick up some classic adventure novels. Find a sport that vaguely interests you, learn more about it and keep up with it. Take up a male-oriented hobby. Push yourself into some male situations that would normally make you feel a bit uncomfortable and out of place.

Immersing myself in male culture started out as an experiment, a desire to try a few new things. To my surprise, I found many things I'd dismissed as 'boring' when I was an adolescent to be peculiarly satisfying as an adult. Each such surprise sparked interest in another new direction. It really was like discovering a new world. Also, as my interests evolved in a more male-oriented direction, I found that I was able to identify with other men much more easily. I saw more and more of them in myself.

If you listen to people define or describe themselves, they often do so in part by listing their interests. An evolution of interests does have a significant impact on the way individuals perceive themselves, the way they present themselves, and the way they are perceived.

Adopt a Masculine Ideal

Earlier, I presented a few productive masculine values that I believe are both fundamental and specifically relevant to the lives of *androphiles*. Personalize this general code of honor and expand it according to your own masculine ideal, your own vision of the man you want to be.

Build a pantheon of productive role models. Start with ten men who embody manliness to you, based on their behavior, their code of conduct or their personal achievements. Select a combination of historical figures, fictional characters from books or films, living men, and men whom you know or have known personally. Since part of the point of this exercise is to reclaim a connection and sense of belonging with other men, at least nine of these should be straight men—don't remain pigeonholed by associating yourself only with other homos. Identify what you find appealing about the role models you've selected; emulate those qualities and look to these men for inspiration.

Surround Yourself with Men

Most homos, even many reasonably masculine ones, have a disproportionate amount of female friends who treat them like 'one of the girls.' One fellow recently admitted to me that he doesn't have a single straight male friend, and this is actually quite typical of gay men over 25. Over time, these men become so culturally isolated and disconnected from other men that they have difficulty forming healthy male friendships with those outside the gay community.

Earlier, I wrote, "Masculine character is rooted in the firm sense that one is a man and belongs among men." If you're unable to maintain friendships and successful associations with men who have not been indoctrinated into gay culture, you'll never really develop a sense of belonging among men. Distance yourself from feminine influences for a while. You don't have to cut off old friends, but make an effort to befriend some straight guys. If you've developed some male-oriented interests and stripped away gay affectations, this shouldn't be that difficult. Treat them like equals, not like potential sex objects or members of some exotic tribe. If you respect their boundaries, share some of their interests, and are easy to hang out with, most adult straight men won't care about your sex life. Developing a healthy sense of camaraderie with other men will ultimately prove extremely rewarding; it will change the way you perceive

homosexuality and masculinity, and it will change the way you perceive yourself.

If you make this a project, if you make a concerted effort to do these things over a year's time, the worst that can happen is that you'll become a slightly more interesting, multifaceted person. However, I believe that many *androphiles* who have not really challenged themselves this consciously in the past will tap into aspects of their own bodies and minds that *want* to be developed. Through cultural and social stimulation, they will awaken a starved *essential masculinity* that will hunger for more of the same. They will gradually dissociate themselves from the stigma of effeminacy, they will become more than half-men—*gay men*—and become vital, confident, *whole* men to be reckoned with.

ANDRO CULTURE – A FRATERNITY WITHIN

It has always seemed like some profoundly ironic cosmic joke to me that the culture of men who love men is a culture that deifies women and celebrates effeminacy. Wouldn't it make more sense if the culture of men who are sexually fascinated by men actually idolized men and celebrated masculinity? The essence of embracing *androphilic* desire is embracing the fact that you actually *are* a man who loves men. As a male who experiences that desire, perceiving yourself to be more womanlike is a cop-out, a compromise that places homosexual desire into a more familiar Mars/Venus polarity; it is essentially *heteronormative*. People *expect* men who prefer sex with other men to be constitutionally effeminate; gay culture conforms to those expectations. A movement of homosexual and bisexual men who *refuse* to conform to those expectations, who refuse to surrender their masculinity, who uncompromisingly relish the fact that they are *men* who love men and embrace that Mars/Mars sexual dynamic would be truly revolutionary. A group of *androphiles* who champion and embody masculine ideals, who go out and earn the respect of other men on their own turf, who actively invalidate the smear of effeminacy by living as exemplary men? Now, that would *really* challenge accepted cultural norms.

The culture of *androphiles* should rightfully be an undiluted, unapologetically male culture. *Androphiles* who exclusively prefer sex with men have the freedom to become almost exclusively *homosocial*, to surround themselves with men and immerse themselves in the world of men in a way that most men simply cannot. With the exception of a few committed bachelors, women are always going to play a significant and moderating role in straight men's lives. Instead of working out Mars/Venus compromises, *androphiles* can create and inhabit completely male-oriented environments, free from feminine influence. In *Where Men Hide*, James B. Twitchell cataloged what he referred to as *redoubts*, places where men go or have

gone to simply be men and escape the wife and kids—places like bars, basements, barbershops, garages, workshops, lodges, deer camps, dens, strip clubs, clubhouses and sporting events. *Androphiles* don't have to hide; they can thrive as men, living a dream life that most other men only *escape* to.

Androphiles have the opportunity to devote far more time to masculine pursuits, to doing the things other men wish they could do more often. I envision a world where *androphiles* become admired as knowledgeable outdoorsmen, avid hunters, successful sportsmen, skilled builders, do-it-yourselfers, shrewd businessmen, and accomplished leaders in their chosen fields. *Androphiles* could become known connoisseurs of male culture, collectors and enthusiasts devoted to the things of men, from war and sports memorabilia to automobiles to male-oriented books, music, artworks and films. As culture becomes increasingly female- and family-friendly, as 'men-only' institutions continue to fall from favor or become integrated, as masculinity is controlled, compromised and redefined according to the preferences and aesthetics of women—as straight men lose touch with their own masculine heritage—I see a role for *androphiles* as masculine purists, unlikely carriers of Mars' ancient torch. Masculinity is a religion, and I see potential for *androphiles* to become its priests—to devote themselves to it and to the gods of men as clergymen devote their lives to the supernatural. What other man can both embody the spirit of manhood and revere it with such perfect devotion? This may sound far-fetched, but is it? If so, then why? Forget about gay culture and everything you associate with male homosexuality. Strip it down to its raw essence—a man's sexual desire for men—and reimagine the destiny of that man. Reimagine what this desire focused on masculinity could mean, what it could inspire, and who the men who experience it *could* become.

The *androphile* is not a fundamentally different kind of man. He shares with other men the same *essential masculinity*, the same experience of maleness. Even if some slight biological differences are ever proved, I believe the experience of maleness

is ultimately far more profound. Sexuality should be no more than a subplot in the story of any man's life. A man's sexual preferences and drives may impact his private lifestyle and some of the choices he makes throughout his life, but to define a man by his sexuality and make sex the dominant theme of his life is shallow and almost always destructive—no matter what his sexual preference is. A man whose life is defined by fucking isn't much of a man at all. *Being male* is the fundamental source of identity for every male—before race, class or creed—and *being a man* affects virtually every aspect of a man's life. Being male affects the way we see and experience the world from the moment we're born until the day we die. All men are men *first*, and *androphiles* should be no exception. For *androphiles*, men are not *others*, they are *brothers* who share this experience of maleness.

The only truly meaningful difference between straight men and *androphiles* is one of desire—the focus of their sexuality. That difference will, however, lead to a slightly different lifestyle, because most *androphiles* will never become fathers. I don't think this is a bad thing. I don't foresee a shortage of children. The trendy Gay Party focus on synthetically creating gay families sets up an unrealistic, counterproductive and *heteronormative* model for what constitutes a fulfilling life by buying into the idea that raising children is the one true path to happiness and social acceptability. I believe *androphilia* is a calling to a different path, a path where happiness is achieved through activity and accomplishment, and fulfillment is found in successful relationships with other men. I also see *androphilia* as a vocation, a call to lead an uncompromisingly masculine life. It's a different life, to be sure, but one that offers many advantages that are seldom acknowledged or exploited.

Androphiles are not a separate race of men, but a brotherhood within the larger brotherhood of men—*a fraternity within* that fraternity. Just as all men share the common experience of maleness, the *Bruderbund* between *androphiles* is the common experience of *androphilic* desire and the different private lifestyle

that develops as a result of that desire. Just as the brotherhood of men is a loose fraternity based on a single commonality, the fraternity of *androphiles* should be a loose association of independent men who have this one thing, *androphilia*, in common.

To be clear, I do *not* advocate the formation of some new cloistered community that offers group hugs and weekend retreats for homos to go beat on drums around campfires and share their feelings about masculinity and homosexuality. Homos are far too segregated from other men as it is; they don't need a new ghetto to huddle away in. They don't need the complete, prepackaged lifestyle that the gay community desperately tries to maintain. What I am advocating is something far more dynamic and interactive. *Androphiles* don't need a distinct common culture, because their common culture and heritage is the one they share with other men. I see *androphiles* as a loose network of men who love men and who love being men, and as a result share some common interests and concerns. There is a long tradition of men forming fraternities based on common interests that do not define their lives, but merely enrich them.

The primary focus of any *androphile's* life should be achieving his personal goals. He should be going out into the world and building rewarding relationships with other men, both straight and *andro*. Take advantage of the flexibility that an *androphilic* life offers, take life by the balls—go out and try new things and pursue those you enjoy. Don't cling to other *androphiles* for support. Association with *androphiles* should only facilitate and supplement the vigorous living of life. *Androphilia* should never be a *raison d'être*; it shouldn't be your whole life and your whole identity, but merely an enjoyable part of what makes you the man you are.

Androphiles must be free to 'be their own men'—to have their own opinions and convictions, their own political and religious beliefs, to lead their lives as they see fit without looking to other *androphiles* for approval. Adolf Brand's magazine—arguably the first periodical specifically for homosexual males—

was titled *Der Eigene*; which translates roughly to 'self-owners.' *Androphiles* should be 'self-owners;' sovereign individuals whose sexuality doesn't define their entire worldview. *Androphiles* can conceiveably be communists or capitalists, Christians or atheists, nationalists or anarchists. If *androphile*s were to work together for a common end, it should only be one that is *directly* related to common issues resulting from their sexuality.

The gay community today includes far too many people with very different interests. The threat of physical oppression that initially drew lesbians, the transgendered, queens and masculine homosexuals together is no longer a pressing threat in the West. There is no longer a need for 'all-for-one-and-one-for-all' lockstep solidarity among these very different groups of people. There is no longer a need for a big, motley surrogate *family* of people who have essentially nothing in common other than the fact that they have atypical sexual preferences and perceptions of gender. The world is factionalized; it's made up of different groups of people with different interests working toward different goals. It's always been that way, and it always will be so long as people are different and have different ideas and values. It's time for The Gay Party to factionalize, so these disparate groups of people can lead their own lives independently of one another and speak for themselves in their own voices.

It is one of the great failures of the The Gay Party as a whole that it advocates males coming to terms with and taking pride in their homosexuality, but never advocates these men coming to terms with and taking pride in being men. The Gay Party *can't* advocate this, because it is in direct conflict with the values of effeminates and lesbian feminists. If homosexual men who *do* find meaning and value in masculinity want to assert themselves as men and lead uncompromisingly masculine lives, they will have to distance themselves from the effeminate gay culture that openly rejects masculinity and believes that homosexuality and effeminacy are inseparable. If queens love the gay culture and the gay identity, *let them have it*! Passive acceptance of the gay identity and membership in the gay community is passive

A Manifesto · 119

acceptance of everything The Gay Party stands for, and passive acceptance of the stigma of effeminacy itself. Only by actively renouncing this identity and culture can masculine homos really free themselves to be men. By truly *being men*—by taking back our masculinity, by reclaiming male culture and heritage as our birthright, by becoming true men of masculine character, by striving toward a masculine ideal and earning the respect of other men—*androphiles* can actively change what it means to be a man who loves men.

AN ESSAY

AGREEMENTS BETWEEN MEN

In recent years, gay advocates, their opponents, opportunistic politicians and the sensationalist media have all worked tirelessly to cast same-sex marriage as an urgent matter of critical importance. Both those for and against same-sex marriage resurrect the issue at every opportunity. In the never-ending battle for leverage in the so-called 'culture wars,' same-sex marriage seems to be nearly as important and polarizing an issue as abortion or the theory of evolution.

Frank Sinatra famously sang that "love and marriage go together like a horse and carriage," and that you "can't have one without the other." It seems logical to many that love, even love between men, must be accompanied by some approximation of marriage. The cultural link between love and marriage is so firm that most of the people who do not oppose homosexuality on moral grounds simply assume that if two guys care about each other, they must naturally want to get married 'just like everyone else.' Many open-minded straights who value marriage, at least theoretically, see bans on same-sex marriage as mean-spirited and regressive. The maudlin portrayals of same-sex marriage presented to the media by gay advocates lead many to believe that virtually all homos out there are just dreaming of the day when they can marry.

That is bullshit, and even those who spin that fairy tale know it full well. Only a minority of homosexual men are truly involved in committed, long-term, completely monogamous relationships that approximate what most people would recognize as marriage. In many cases, the members of that minority are morally appalled by how overwhelmingly commonplace promiscuity and 'open relationships' are within the gay community. They believe marriage is the only way to curb their fellows and thereby make homosexuality presentable to their buttoned-down friends and families. However, because support for same-sex marriage has become the politically correct position within the gay community, many of those who support same-sex marriage these days don't even have steady boyfriends. Most value the romantic ideal of marriage far more in theory than in practice.

There's a solidarity today among homos on the marriage issue that's somewhat misleading, even reactionary. Homosexual men who have no intention of ever getting 'married' in any conventional sense, who either believe that the institution of marriage is flawed and failing or who simply find it personally undesirable *still* seem to feel compelled to support same-sex marriage 'rights' for others—as if it is their duty to do so. There's an unwillingness to break the line on this issue, and this false front of spiritual solidarity is probably maintained more in knee-jerk reaction to the insulting rhetoric of same-sex-marriage opponents than because it represents something most homos actually want or desperately need. Default support for same-sex marriage also has to do with the way in which same-sex marriage advocates have framed the issue.

Opposition to same-sex marriage has been positioned as an affront to 'equality.' Normally sensible homosexuals have been led to believe that marriage is a 'right' they are being denied and that their 'freedom' is being restricted. Whether they actually want to get married or not, they are indignant about being treated like "second-class citizens."

The broadest base of support for same-sex marriage among

homosexuals stems from a desire to prove something akin to the old folk etymology for *gay* as an acronym: 'Good As You.' Demands for same-sex marriage are not so much about the institution of marriage itself as they are about validation and acknowledgment. Gays desperately want the public to recognize that their relationships are 'as good as' straight marriages.

Many gays also seem to suffer from some sort of *gay exclusion paranoia*. So many of them have felt excluded or ostracized or belittled in the past that if they are made to feel as though they're being excluded from anything, they'll fight tooth-and-nail to be included, whether they genuinely want to participate or not. Similar to the way in which feminists demanded to be admitted to all-male institutions and clubs, gays want what they want in many cases simply because they've been told they can't have it. It's more a matter of principle than a matter of practicality. It's likely that marriage also seems exponentially more desirable to them simply because it is forbidden. Will they really want it so badly when they finally get it…after the novel becomes commonplace?

Because most cultures authorize and legitimize sexual relationships through the institution of marriage, same-sex marriage advocates believe that it would be in the best interest of all homosexuals if they had the opportunity to legitimize their relationships in *exactly* that way. I say *exactly*, because many same-sex marriage advocates believe the word *marriage* is absolutely essential. They frequently make ham-fisted, dubious references to black civil rights battles, and consider anything different, even in name, from *marriage* to be 'separate but equal.' As a bonus, making melodramatic references to famous civil rights battles against racial discrimination leverages white guilt—effectively portraying even the most reasonable and rational opponents of same-sex marriage as being no different from sheet-sporting racist bigots.

Although same-sex marriage advocates commonly refer to the legal benefits of marriage, these benefits are invoked only as supporting arguments that serve the primary goal of including

homosexuals in the institution of marriage and validating their relationships in the eyes of society. Concerns about simple things like being allowed to visit a loved one in the hospital during an emergency seem reasonable and valid, but these are trotted out only to tug at the heartstrings of the otherwise-unsympathetic. The handful of human tragedies portrayed in maudlin gay propaganda could more easily be solved by reforming health care policies, and are peripheral to the central arguments for same-sex marriage.

There are many rarely explored pragmatic arguments against extending the oft-cited legal 'rights, benefits and responsibilities' of marriage to homosexual couples. Obviously, contemporary marriage has a rather poor rate of success among straight people. For every 'happily ever after' scenario, there is a marriage that doesn't end so happily, and the mechanism of divorce can cause far more financial and emotional stress than a breakup that doesn't involve lawyers or the court system. Same-sex marriage will be great for divorce lawyers, but bad for homos—many of whom will suffer far more from having been married than they would have suffered from not being able to marry. And even if the union results in perpetual marital bliss, not all of the 'benefits' of marriage are necessarily beneficial, depending on a couple's financial situation. Any such rational wariness about the institution of marriage is waved away as 'defeatist mentality' by gay-marriage idealists. To them, the details don't matter; the big picture doesn't matter. It doesn't even matter if marriage is truly the resounding success they believe it will be, based purely on dreamy hopes and speculation. To same-sex marriage supporters, it's the principle of the thing that matters.

However, my argument *against* marriage between men is also an argument based on principle. The various legal pros and cons of civil marriage are besides the point. What really rubs me the wrong way is applying the cultural institution of marriage to a relationship between two men.

Relationships between men can certainly be 'as good as' relationships between men and women. Actually, in light of my

personal experience, I daresay they have the potential in many ways to be *better than* relationships between married men and women. But the two relationships *are* different, because men and women are different. Sexuality is not race. A black man and a white woman are still a man and a woman. They're still likely to have children as a result of sex, and it is in the best interest of society that they form a strong bond and stay together. This is simply not the case with two men.

To me, whether I am legally allowed to marry another man or not isn't an equality issue. I don't care about petty perceived slights against equality. I'm not concerned about making absolutely certain I'm being treated exactly the same as everyone else. I don't just want a bond that makes me feel 'equal.' I want something *better*. I want something that makes more sense for two men. I don't think homosexual men, as a group, will benefit from inheriting all of the baggage associated with an anachronistic, embattled institution that was never designed to accommodate the distinctive character of their relationships. I believe they are far better off handling their own affairs and negotiating their own private agreements. And if they adopt a tradition, it should be one that is in harmony with the unique character of bonds between men.

Marriage is not a 'freedom', and it is not a 'right.' Marriage is an institutionalized social control. It's a cross-cultural solution to the basic problem of attraction between the sexes that attempts to promote the most stable environment for the rearing of the children that a man and a woman are extremely likely to produce. The fact that some married couples do not or cannot produce children is incidental to the fundamental purpose of marriage. Marriage has historically forced men, who are statistically far more likely than women to abandon their children otherwise, to take responsibility for those children. Additionally, because women have only recently gained the opportunity to support themselves financially, marriage has traditionally ensured that females would be cared for outside of their parents' homes. The institution of marriage evolved primarily to care for women and

children. The state has taken an active role ensuring the support of single mothers, and women no longer need men to financially support them. These are two key reasons why, today, many marriages do not last. There are other mechanisms in place that achieve the primary goal of marriage, and the responsibilities that once fell squarely on the shoulders of men are now more evenly distributed, and are at any rate easily shifted. Men know that women can care for themselves on their own, and if *both* parents abandon their children, *someone else* will care for them. At its most basic level, the institution of marriage is not a 'right' or a 'freedom' but a social and legal solution to a problem two men simply do not have.

To same-sex marriage advocates, marriage is really just about love. But marriage for love alone is a relatively new thing. Effective birth control is a new thing. Many straight couples today get married for love, but for most of them marriage remains the first step in building a family. It still makes a modicum of sense for society to be involved in promoting a stable, long-term, legally binding union for the benefit of any children that a couple may produce, either by design or by accident. Because two men can't reproduce, the same rationale does not exist for involving the rest of society in ensuring they remain bound together. Because children are not naturally a factor, communal involvement in a sexual relationship between adult men to promote monogamy or stability 'for their own good' smacks of nanny-state busybodyism. Sexual relationships are private matters, and there is no good reason why communities, or even families, need be involved in what have always been private agreements between men. Two self-supporting adult men should be *expected* to take responsibility for their own happiness, and work out their living situations and personal relationships on their own.

For some advocates, institutionalizing same-sex marriage is a thinly veiled attempt to impose a moral ideal that they value on all homosexual men, creating a hierarchy of legitimacy for male/male relationships with marriage as its pinnacle. Most of these guys are either religious gays who seek an approximation

of the union spiritually endorsed by their religion, or romantic idealists who have seen one too many chick flicks. (Often, they are both.) There's really no talking to either group because to both, marriage is a gilded, magical thing that's been placed on a pedestal and filmed in soft focus. For both, marriage is the ultimate evolution of love. Any other arrangement is less than ideal in their eyes, no matter how much sympathetic lip service they charitably pay to the regrettable eccentricities of their peers. But what they aspire to will always be an imitation of something that has thousands of years of history behind it, something that has been celebrated and romanticized in art, literature, theater and…those chick flicks. Though they assert that their relationships are 'as good as' marriage, their marriages will never be quite the same.

Men and women are different. If they weren't, there wouldn't be so many books of the *Men Are From Mars…Women Are From Venus* ilk out there to help the two sexes figure each other out, and a lot of marriage counselors and talk show hosts would be out of work. I've been the confidant of both straight men and straight women over the years, and in most cases the differences in male and female psychology are so pronounced that I'm really quite amazed they *ever* manage to get along. Men and women have different wants and needs, and they process and interpret information very differently, especially when it comes to romance. Only in a postfeminist world would I even have to write this. It used to simply be common sense. And it still is, in the everyday world. We easily recognize and laugh at the obvious differences between the sexes all the time when they are comedically presented in film and on television. But when it comes to writing things down, folks are far too careful. Most writers avoid angry feminist critiques by attempting to minimize or discount sex differences—unless they are therapists who get paid to acknowledge those differences and help people make sense of them.

Sexual relationships between men were forced underground for so long that very little exists in the way of example when

it comes to models of long-term bonds. The cultural catalog expressing love between men and women is endless. There have been poems, songs, myths, paintings, plays and films about virtually every possible love scenario between men and women imaginable. Raised in the same society as everyone else, it is understandable that homosexuals would idealize their relationships following a male/female model. They simply paste in someone of the same gender instead of the opposite, make a few quick adjustments, and move on. However, the way that romance and courtship are conceptualized—the whole history of what is called 'romance'—is an expression of the specific emotional exchange between men and women.

What is considered 'romantic' is so often just men prostrating themselves before the altar of the vagina. Romance is an elaboration of courtship; it's men doing things they wouldn't normally do to make women feel special and desirable. Few men are concerned with buying flowers, offering chocolates, picking a special song, remembering anniversaries, having candlelit dinners, or doing virtually any of the things associated with cinematic, 'Valentine's-Day-style' romance. Men do these things because women want them to—and because they usually lead to sex. What is romance if not just some big dance to get into some girl's pants? (Or the perennial celebration of said quest for the benefit of women, to reassure them they are still desired?) Most women have distinctly different needs, different interests and generally have a different aesthetic sensibility. Romance caters to this sensibility. Romance affirms a woman's femininity; it affirms her mythic role as a sensual goddess and sexual gatekeeper.

When I hear gay men wistfully talking about romance, I just don't get it.

I'm a guy. I don't need or want my femininity affirmed. Everyone wants to be appreciated, but men show each other appreciation in different ways. I don't want to be swept off my feet or romanced. I don't want some guy bringing me flowers and I don't need him to make me feel special and pretty.

In fact, after a few times I think I'd find that insulting and emasculating—as would most straight fellas if their girlfriends started treating them like princesses. If you think I'm desirable, initiate sex. If you love me, make me a sandwich when you make one for yourself. Make some sort of personal sacrifice for me. But I don't need to be doted on or fawned over or put on a pedestal. If you want to make a man feel good about himself, you don't treat him like he's delicate and pretty—you make him feel strong and capable and self-sufficient. Men want to feel like heroes, conquerors—maybe even villains—but never damsels in distress. Queens love to play the role of damsel-in-distress only because they imagine themselves to be womanlike and take women as their role models. For men who aren't performing that clichéd shtick, even less theatrical acknowledgments of frailty, ineptitude or powerlessness are uncomfortable at best.

I've seen so many gay movies that imitate straight romantic scenarios in virtually every detail, portraying homosexual men as if they were plain Janes pining away, hoping against hope that the quarterback of the high-school football team would ask them to the prom. This is not my fantasy. It has nothing to do with my life. Frankly, it's fucking gay. Gay romance is a borrowed dream. Same-sex marriage is a borrowed dream. It's a bait and switch. We're all supposed to want this romantic ideal of husband and wife that society celebrates, so gays switch out a woman for a man and call it good without acknowledging what that switch really means, or what it really changes. Instead of acknowledging the different dynamic between two men and the different ideal it could engender, we're all supposed to walk along whistling as if we were none the wiser. Encouraging two men to adopt a male/female romantic ideal is asking them to be something they simply are not. It's essentially saying that the unique dynamic between two men is in fact not 'as good as' a straight relationship unless it is an awkward reflection of the traditional heterosexual romantic ideal. Expecting homosexual men to live up to an ideal so ill fitting is unrealistic, stifling and potentially harmful. It also seems a bit sloppy and

unimaginative.

Relationships between men have their own character, more akin to other bonds between men than to romance between men and women. Love between men is less 'Romeo and Juliet' than it is 'Joey and Chandler.' Or 'Bert and Ernie.' There is something distinctly fraternal in the emotional exchange between two men over time, even if their relationship is sexual. Men understand each other better; they're playing from the same handbook. That Mars/Venus push and pull is absent. Romance and gender conflict are exchanged for a more intense version of the Mars/Mars camaraderie that brothers and best pals enjoy. There's no need for the elaborate courtship rituals; there's no demanding vaginal goddess to placate with sacrifices of masculinity. Men tend to crave sex more regularly, and masculine men don't require the same sort of reassurances—as women do—that they are loved before and after the act. They're better able to separate sex from other emotions. And, being naturally less emotional or at least less emotionally erratic, men are more likely to work things out with one another in simple, practical terms. Instead of presenting love between men as a mere approximation of the masculine/feminine romantic mythos, why not acknowledge the natural fraternal character of the male/male bond and draw inspiration from *that* tradition?

The folly of same-sex marriage is best symbolized by the familiar two grooms on a wedding cake. Marriage is a mountainous, multilayer, white-frosted cultural confection, and gays simply commandeer it by knocking off the bride and substituting a second groom. They ignore the substantive foundation of the cake itself—the layers of historical meaning and tradition and the fundamental purpose of marriage—and make a hasty, superficial switcheroo. Same-sex marriage is graffiti on the Parthenon; it's Andy Warhol. It's hollow pop appropriation. Same-sex marriage is the fetishization and repurposing of something mechanically, automatically revered by many.

Why is the cake white? Why is there a cake? Why is there

a ceremony? Why is the bride 'given away'? Who is the bride? Why the veil? Why the garter? Why the rings? Whose family should foot the bill? Who tosses the bouquet? Why are there gifts, and why do people care enough to give them? What are the vows? What do they mean? Why were they written the way they were written?

Virtually every tradition, every movement, every symbol, and every symbolic gesture that is part of the usual marriage ceremony and every expectation about the bond created during that ceremony is rooted in tradition. These things *mean something*, something that has absolutely nothing to do with two men or two women. To render gender irrelevant by saying that marriage is really only about love is a gross oversimplification. Marriage is a ritualized institution designed specifically for men and women in almost every aspect. Only in a relativist's world wherein gender is meaningless—and *meaning* is meaningless—could the idea of a same-sex marriage ceremony be anything but an exercise in absurdity.

The tradition of marriage is aesthetically and emotionally designed to accommodate and emphasize a feminine element that is lacking in a male/male bond.

Marriage caters to women. Brides-to-be are almost always far more involved—sometimes frighteningly so—than men in planning their ceremonies and receptions, hence the taunt: "Bridezilla." Weddings are for the most part female-oriented affairs replete with flowers and all sorts of decorative girly ephemera. I've seen two sisters and some friends plan weddings, and the groom almost always tends to take a step back—commenting only when he finds something deeply distasteful. (Dispute this if you like, but do note the circulation of bridal magazines for women and the conspicuous absence of anything remotely similar for grooms.) It's not that wedding ceremonies aren't meaningful to men; it's often the *men* who tear up during the ceremony. But it is almost universally understood that a wedding is *her* special day. Almost every little girl begins daydreaming about her wedding at a very young age. Even

dolls come with wedding dresses. While the wedding rehearsals may not *officially* begin until a few days before the wedding, brainstorming sessions and dry runs are often well under way before girls enter preschool. Little boys are raised to assume that they'll get married eventually; it's presented as a step in a successful man's life path—more like a graduation than the aspirational fantasy it is for females. Some men, especially creative men who see it as a challenge or a fun project, do get involved in the planning of their weddings. But let's be honest here; for the most part, weddings are a chick thing. That's fine, but what the Hell is the point of encouraging a bunch of guys to go through the motions of something that is essentially the romanticized presentation of a beautiful virgin?

This may sound crass, but even after being with my compadre for the better part of a decade, the idea of the two of us walking down some aisle and exchanging vows before our families still seems like a bad, fish-out-of-water comedy skit. I love the guy more than anyone on the planet, but I can't imagine getting through the thing without breaking into fits of uncontrollable laughter. And what am I going to do at the reception? Dance with my dad? Should my aunts and uncles tap their champagne glasses until we kiss? Have people really thought this out? It's not that I'm embarrassed or ashamed of being an *androphile*, but there's something deeply comical and more than a little unmanly about two men getting married according to a heterosexual tradition. It's funny in the way a fat bearded guy in a dress is funny.

Instead of glossing over the differences between men and women and pretending that the relationship between two men is the same as the emotional exchange between a man and a woman, it makes a lot more sense to explore the uniqueness of that relationship and develop a tradition that makes sense for men. Bonds between men aren't something to be dismissed simply because the bonds between men and women are so exalted. There is a tendency in modern, postfeminist culture to make light of or even snicker at male friendships and male

traditions. However, the history of male bonding is actually quite rich and inspiring in its own way. Bonds between men are different from bonds between husband and wife, but they are far from meaningless. Some straight men form such strong bonds that each guy would gladly take a bullet for the other. Is *that* trivial?

Acknowledging difference does not mean acknowledging inferiority, as the hysterical evangelists of 'equality' believe. So many gays pay lip service to the notion that 'diversity' is something to be cherished, but they seem Hellbent on establishing not diversity, but artificially imposed sameness. Bonds between men have a unique character. That's not something to be ashamed of or swept under the rug. Men who love men deserve their own tradition; they deserve the opportunity to develop something that may or may not resemble marriage at all, but which is shaped by the distinctive experience of Mars/Mars interaction and by the real nature and the real needs of men.

Why not draw from the rich traditions of close fraternal bonding between men and develop *those* traditions into something aesthetically and conceptually suitable for *androphiles*?

For instance, there is a cross-cultural tradition of men becoming 'blood brothers.' It seems to be instinctively appealing to men; young boys often learn of this tradition and become brothers via some intermingling of blood. Love between *androphiles* simply adds a sexual element to a close male friendship, and the idea of creating a sense of brotherhood could provide a means of creating family that better befits the nature of the relationship itself. There's a potent symbolism to the idea of sharing blood that has proved extremely meaningful for men who loved each other in a platonic way over the millennia. Sharing blood could mean vowing to care for another man's body as if it were your own. Conceptually, if not technically, each brother always has the other's blood running through his veins. This is a union in the most meaningful sense, but also in a specifically masculine sense.

Today there would obviously be concerns about the spread

of disease through such a practice, but this isn't a bond that should be entered into any more lightly than marriage. If one partner does happen to have a blood-borne disease, there are also traditions wherein the blood is combined in a vessel and poured onto the earth—so that the blood of the men remains mixed there forever.

A twist on the idea might be something as accessible as getting a pair of matching tattoos at the same time—something sailors and military men have long done together to create a sense of brotherhood. There are certainly other rituals that men have performed throughout history to bond themselves to one another, up to and including modern fraternity hazing, and these uniquely masculine expressions of love merit exploration by *androphiles*. Men already have ritualized mechanisms for bonding. There's no need for two men to go through the motions of being a man and a woman.

The difference between most blood brother rituals and the spectacle of modern marriage is that blood brother rites usually tend to be private, meaningful, organic exchanges between men while marriage ceremonies are lavish, showy, public affairs. With two men, there is no joining of gene pools, there are no biological children, there is no true need for acknowledgement between two families. There is no need for the community to broker this deal, because the community really doesn't suffer if the two men go their separate ways. Men are expected to be self-sufficient whether they are married or not. Why should the community be any more involved in their private lives than it is in their ability to financially support themselves? Is something automatically more meaningful because it is said before others? Isn't it possible that some things are best kept private, that some emotions are in fact cheapened when showcased, spotlighted, and exhibited for the comment, evaluation and approval of relatives and relative strangers alike? Is love only valid if it's properly validated?

As a man, I find the private agreement to be even more meaningful and a bit more dignified than the public one. A

private pact wherein each man sets his own terms reinforces the masculinity, sovereignty, and independence of the men involved. As time goes on, they may reconsider the terms of that agreement to assure it remains mutually satisfactory. In the context of a private agreement, men choose to be together completely of their own accord, and it is this element of choice that I value most about my own relationship. I am not with my compadre because of our families, or because society says it's the right thing to do or because I entered into a contract with him in public. If we separate, no one else will really be inconvenienced, and we will not be scorned any more than we would have been anyway. We are two men of independent means who in some sense choose to be together every day. We remain together and take care of each other because we want to, not because we have to. We are bound not by law, but by our own free wills. That is freedom, folks—not having the state lay down some one-size-fits-all standard that determines the most desirable way for grown men to conduct their private lives. The bond my compadre and I share is something that brings us happiness and fulfillment privately, but if we were to grow apart, that too would be a private matter. This privacy makes our pact *more* meaningful to us. Our arrangement is our own, and involves no one else. It is 'just between us.' It is an agreement between men.

 I wouldn't want it any other way.

APPENDIX

SELECTED BIBLIOGRAPHY

The ideas and opinions expressed in *Androphilia* were inspired by countless interactions and conversations I've had with *androphiles*, gay men, straight men, and women over more than a decade. These were truly my primary sources, in addition to my own observations of the gay community and portrayals of homosexuality in the media and contemporary culture. The following books, articles and web sites also provided valuable insight and information.

ARTHUR, GAVIN. *The Circle of Sex.* University Books, 1966.
BURG, B. R. ed. *Gay Warriors – A Documentary History from the Ancient World to the Present.* New York University Press, 2002.
CANTARELLA, EVA. *Bisexuality in the Ancient World.* 2nd Ed. Yale University Press : 1992-2002.
CAREY, BENEDICT. "In Men, 'Trigger-Happy' May Be A Hormonal Impulse." New York Times. May 9, 2006.
CROMPTON, LOUIS. *Homosexuality and Civilization.* Belknap Press of Harvard University Press, 2003.
FIELDEN, J., C. LUTTER, and J. DABBS. "Basking in glory: Testosterone changes in World Cup soccer fans." Psychology Department. Georgia State University. 1994
FRIEDMAN, DAVID M. *A Mind of Its Own : A Cultural History of the Penis.* Penguin Putnam, Inc., 2001-3.

FRITSCHER, JACK. *Some Dance to Remember.* Knights Press, Inc., 1990.

GENET, JEAN. *Querelle de Brest.* Tr. Steatham, Gregory. Anthony Blond Limited, 1966.

GENET, JEAN. *The Theif's Jounal.* Grove Press, 1964.

GILMORE, DAVID D. *Manhood in the Making : Cultural Concepts of Masculinity.* Yale University Press, 1990.

GREEBERG, DAVID F. *The Construction of Homosexuality.* University of Chicago Press. 1988.

HARRIS, DANIEL. *The Rise and Fall of Gay Culture.* Ballantine Books, 1997.

HOOVEN III, F. VALENTINE. *Tom of Finland : His Life and Times.* St. Martin's Press, 1993.

LAVEY, ANTON SZANDOR. *The Satanic Witch.* 2nd Ed. Feral House, 1970-2003.

MANSFIELD, HARVEY C. *Manliness.* Yale University Press. 2006.

MISHIMA, YUKIO. *Sun and Steel.* Tr. Bester, John. Kodansha, 1970.

OOSTERHUIS, HARRY; KENNEDY, HUBERT., ed. *Homosexuality and Male Bonding in Pre-Nazi Germany.* Harrington Park Press, 1991.

PAGLIA, CAMILLE. *Sexual Personae : Art and Decadence from Nefertiti to Emily Dickenson.* Vintage Books, A Division of Random House, Inc., 1990-1.

PAGLIA, CAMILLE. *Vamps and Tramps.* Vintage Books, A Division of Random House, Inc., 1994.

PLATO. *Symposium and Phaedrus.* Tr. Jowett, Benjamin. Dover, 1993.

RAMAKERS, MICHA. *Dirty Pictures : Tom of Finland, Masculinity, and Homosexuality.* St. Martin's Press, 2000.

RECHY, JOHN. *City of Night.* Grove Press, 1963-1984.

RECHY, JOHN. *The Sexual Outlaw.* Dell, 1977.

RHOADS, STEVEN E. *Taking Sex Differences Seriously.* Encounter Books, 2004.

ROBB, GRAHAM. *Strangers : Homosexual Love in the Nineteenth Century.* W.W. Norton & Company, Inc., 2003.

SIMPSON, MARK. *Anti-Gay.* Freedom Editions, 1996. Cassell, 1999.

SULLIVAN, ANDREW. *Virtually Normal.* Alfred A. Knopf, 1995.

SURESHA, RON JACKSON. *Bears on Bears.* Alyson Publications, 2002.

SYKES, BRYAN. *Adam's Curse : The Science that Reveals Our Genetic Destiny.* W.W. Norton & Company, 2003-5.

Szasz, Thomas. *The Second Sin.* Anchor Books, 1974.
Tiger, Lionel. *The Decline of Males.* Golden Books, 1990.
Twitchell, James B. *Where Men Hide.* Columbia University Press. 2006.
Tyre, Peg. "The Trouble With Boys." *Newsweek,* 30 Jan 2006: 44-52.
White, Edmund. *Genet : A Biography.* Vintage Books, A Division of Random House, Inc., 1994.
Yu, Li. *The Carnal Prayer Mat.* Tr. Patrick Hanan. Ballantine Books, 1990.
Zeeland, Steven. *The Masculine Marine.* Harrington Park Press. 1996.
Zeeland, Steven. *Sailors and Sexual Identity.* Haworth Press. 1995.

Selected Online Sources

Andrew Sullivan – andrewsullivan.com
GLAAD – glaad.org
Human Rights Campaign - hrc.org
Independent Gay Forum - hrc.org
Mark Simpson - marksimpson.com
National Gay and Lesbian Task Force - thetaskforce.org
Peter Tatchell - petertatchell.net

Films Referenced

Fight Club (1999)
Fireworks (1947)
Gods and Monsters (1998)
Scorpio Rising (1963)
The Deer Hunter (1978)

ACKNOWLEDGMENTS

I'd like to thank my compadre, Lucio, for making many sacrifices so that I could concentrate on writing, and for patiently listening to me think out loud over the years. He's the most important person in my life, and I owe him a big screen television.

It was Kevin I. Slaughter and Chris X at Scapegoat Publishing's interest that ultimately turned this into a serious project.

I'd also like to thank all of the men who read drafts of the manifesto and offered their comments. Peter H. Gilmore's encouragement was inspiring and his ongoing input was absolutely essential. 'Herr Paul' Smalley read a draft for me over pizza and we hashed through ideas on many enjoyable occasions. I'd like to thank Nathan F. Miller for his insightful comments throughout this project's development, and for first suggesting to me the idea that some sort of 'blood brother' bond might be an excellent, masculine alternative to 'marriage.' That was his idea, and I hope that we can both explore it in greater depth in the future. Jeremey Livingston assisted with thorough, razor sharp critique when it was absolutely necessary.

Thank you to Mark Simpson for reading through this manifesto and offering a comment before we went to press.

I'd also like to thank the unnamed writer I referred to in my introduction, who, while ultimately uncomfortable with some

key concepts I presented, generously took the time to red line the entire manuscript and inspired some critical revisions.

Other friends and associates who provided feedback, insight and support throughout the writing and publishing process were Brian Winchell, Michael J. Spear, Andy G. Freeze, Lestat Ventrue, Diabolus Rex, Ken Meyers, Simon j.d. Knight, Welpe, Clarence Williams, Justin Kolar, Tim Stokes, Bryan Porter, Leif Kailian and Gryphon MacThoy. Thanks, guys.

I've spent a lot of time commenting on *The Malcontent* blog (http://www.malcontent.biz/blog/) over the past year or so, and I'd like to thank Matt and Robbie for tolerating my intransigent presence. Because they provide an unusually neutral zone that attracts fairly intelligent homos of liberal, moderate and conservative persuasions, I was able to work through a lot of arguments that eventually made their way into *Androphilia*. My opinions were informed and developed, if rarely altered—this book was not written in a vacuum.

I'd even like to thank the gays out there who think I am, as one fellow put it, "a perfectly vile queer," because they constantly reminded me why I was writing this manifesto in the first place.

ANSWER Me!: The First Three by Jim Goad

8"x10.5" ISBN 0-9764035-3-6

This fat, gorgeous, ridiculously underpriced anthology contains the legendary hatezir FIRST THREE ISSUES in their entirety. It also contains SIXTY NEW PAGES of wist *ANSWER Me!* memories and tasty new articles written by philanthropist and humanitar Jim Goad. There's a strong chance that this is the best book ever published. Only an id would refuse to buy it.

> "ANSWER Me! came on like a no-popes crusade to blast through the vacuum and kill or convert the czars of political and aesthetic correctitude."
> - Adam Parfrey, Feral House

Stephen Kasner: Works, 1993-2006

10.75"x10.75" Hardback ISBN 0-9764035-5-2

10.5"x10.5" Paperback ISBN 0-9764035-6-0

An extensive compendium of the paintings, drawings, photographs and prints o contemporary artist who's symbols translate into a stellar vocabulary depicting strife of human animal against the austerity of nature. Covering thirteen years of artistic developm and exploration, *Stephen Kasner: Works* offers a comprehensive collection of Kasner's orga depictions of figures and animals, birds and flowers, landscapes and interiors, co-ming in bursts of self-discovery.

Dreamlike and vast, these vistas interpret human emotion and psychological struggl tandem with the harshness of nature and how combinations of delights and disasters a our personalities, striving toward relief and a yearning for euphoria.

Working primarily in oil on canvas and paper, the works compiled in this thirteen retrospective cover Kasner's sketches, studies, figurative works, full-scale works, photogra and printmaking, the latter of which lies predominantly unexhibited and unpublished to d

To be published:
The Satanic Scriptures by Peter H. Gilmore
Circus Parade: A Cruel Novel by Jim Tully

www.ScapegoatPublishing.com